Hillert Ibbeken

Das andere Italien
The other Italy

Geschichten und Bilder
aus Ligurien und Kalabrien

Stories and pictures
from Liguria and Calabria

Edition Axel Menges

© 2011 Edition Axel Menges, Stuttgart/London
ISBN 978-3-936681-43-7

Reproduktionen/Reproductions: Reinhard Truckenmüller
Druck und Bindearbeiten/Printing and binding: Graspo
CZ, a.s., Zlín, Tschechische Republik/Czech Republic

Lektorat/Editing: Dorothea Duwe
Übersetzung ins Englische/Translation into English:
Michael Robinson
Layout: Axel Menges

Photo auf dem Umschlag: Krippenfiguren im weihnacht-
lichen Cabella Ligure
Photo on the jacket: crib figures in Christmassy Cabella
Ligure

Inhalt

Contents

Das andere Italien. Geschichten und Bilder aus Ligurien und Kalabrien

Das andere Italien, was ist das, was mag das sein? Wenn es das andere Italien gibt, müßte es dann nicht auch das eine Italien geben, das eine und das andere? Ich möchte an dieser Stelle keine besondere Italien-Gliederung oder Nomenklatur einführen, es geht mir lediglich um meine persönliche Unterscheidung der beiden Italien, dem einen und dem anderen. Das eine ist für mich das Italien mit seinen wunderbaren Städten und unermeßlichen Kunstschätzen, ich kenne es nur wenig, bewundere und verehre es jedoch sehr. Und das andere ist das ländliche Italien, fernab vom Getriebe der Städte, das Italien des Apennin, der entlegenen Dörfer, Kirchen und Klöster, der Bauern, Köhler, Hirten und Fischer, auch wenn diese alten Berufe immer seltener werden. Diesem anderen Italien gehört meine ganze Liebe. In mehr als fünfzig Jahren habe ich es in Hunderten von Kilometern durchlaufen und in Tausenden durchfahren. Durchwandern zu schreiben träfe es nicht, denn der Wanderer will sich eine Landschaft kontemplativ aneignen und sucht gezielt ihre gerühmte Schönheit, ihren Charakter. Ich dagegen bin als Geologe durch Berg und Tal gezogen, kartierend mit Hammer und Karte, Fernglas und Lupe, Kompaß und Höhenmesser. Daß man auf diese Weise Land und Leute fast intim kennen- und liebenlernt, kann nicht ausbleiben. Die Schönheiten und Charaktere der Landschaften teilen sich dabei ganz von selber mit.

Wir erinnern uns: Italien, der italienische Stiefel, ist eine langgestreckte gebirgige Halbinsel, die sich schräg, nahezu diagonal von Nordwesten nach Südosten durch das Mittelmeer zieht, fast 1000 Kilometer lang und meist nur etwa 200 Kilometer breit, zuweilen etwas breiter, zuweilen etwas schmaler. An der südlichen Spitze des Stiefels, fast wie ein Fußball vor dem Schuß, liegt Sizilien.

Italien ist das küstenreichste Land Europas, es besitzt 7600 Kilometer Küste. Damit erklärt sich wie von selbst, daß *bella Italia* auch ein Badeland ist, welches Heerscharen von Touristen anzieht. Hinzu kommen die Annehmlichkeiten des mediterranen Klimas.

Die Italien umgebenden Meere sind die Tyrrhenis im Westen und die Adria im Osten. Im Norden, wo der Gebirgsbogen der Halbinsel in die Alpen übergeht, liegt das Ligurische Meer mit Genua in seinem Scheitel. Gegenüber, wo der aus der Poebene kommende Po in die nördliche Adria mündet, liegt Venedig. Im Süden der Adria, am Absatz des Stiefels, sind Italien und Albanien nur wenige Kilometer voneinander entfernt, denn die Adria verengt sich hier zur Straße von Otranto, um sich dann zum Ionischen Meer hin, das zwischen dem Fuß des Stiefels und Griechenland liegt, wieder zu öffnen.

Italien ist in 20 Regionen aufgeteilt. Ligurien und Kalabrien, die beiden Regionen, um die es hier gehen soll, sind sehr leicht zu finden. Das schmale, langgestreckte gebirgige Küstenland Ligurien, eine der kleinsten Regionen, begleitet das gleichnamige Meer von der französischen Grenze im Westen – Ventimiglia und Savona liegen hier – über Genua in der Mitte und etwas über La Spezia hinaus nach Osten, wo es gegen die Apuanischen Alpen und damit an die Toskana stößt.

Es ist hübsch und sinnfällig zweigeteilt, mit Bezug auf das in der Mitte liegende Genua. Der östliche Teil, rechts, ist die Riviera di Levante, wo morgens die Sonne aufgeht, und der westliche, links von Genua, die Riviera di Ponente, wohin sich die Sonne abends zur Ruhe begibt.

So existieren an der ligurischen Küste zwei Orte, die beide Sestri heißen, Sestri Ponente im Westen und Sestri Levante im Osten von Genua.

Die nördliche, landseitige Grenze Liguriens ließe sich am einfachsten mit der apenninen Wasserscheide darstellen und erklären, die aber so oft überschritten wird, daß deren Beschreibung hier nicht geleistet werden soll, mit einer Ausnahme: Die zentrale ligurische Provinz Genua reicht weit über die Wasserscheide nach Norden, in vergangenen Zeiten sogar noch weiter als heute, wie viele Ortsnamen verraten, denen heute noch ein *ligure* angehängt ist, Cantalupo Ligure, Rocchetta Ligure. Am Monte Carmo, mit 1640 Metern einer der höchsten Berge dieser Gegend, kommt Ligurien dem berühmten Tripelpunkt bis auf wenige Kilometer nahe, wo sich die großen Regionen Piemont, Lombardei und Emilia Romagna berühren. Dort habe ich jahrelang gearbeitet, und der Leser wird verstehen, daß ich immer Schwierigkeiten hatte, Außenstehenden die Frage nach dem Wo meiner Arbeit exakt zu beantworten. Wenn ich also im folgenden einfach von Ligurien spreche, dann steckt darin auch sehr viel Piemont und ein wenig Lombardei. Das liegt aber eigentlich nur daran, daß die Lombardei gerade hier einen dicken Zipfel weit in den Süden schickt.

Nun zu Kalabrien, das ganz einfach den Fuß des italienischen Stiefels bildet. Links auf der Spanne liegt das Tyrrhenische Meer, rechts, an der kitzeligen Sohle, das Ionische Meer. An der Straße von Messina, von wo aus der Blick auf das nahegelegene Sizilien und den oft schneebedeckten Ätna Vulkan geht, befindet sich Reggio di Calabria, die Hauptstadt.

Die beherrschenden Gebirge Kalabriens sind der Pollino im Norden, die Serre und die Sila in der Mitte und der Aspromonte, der dunkle Berg ganz im Süden, er wird gekrönt vom 1955 Meter hohen Montalto. Hier, sozusagen am großen Zeh des Stiefels, ist Italien keine 50 Kilometer breit.

Die hier behandelte ionische Flanke des südlichen Teils von Kalabrien reicht vom südlichsten Punkt des italienischen Festlands bei Melito di Porto Salvo bis Monasterace Marina, dieser Streifen ist etwa 100 Kilometer lang und, bis zur Wasserscheide, etwa 20 Kilometer breit. Das Klima zeigt sich hier unten sehr uneinheitlich. Im Sommer ist der Küstenstrich heiß und trocken, im Frühjahr und im Herbst regnet es, und zwar weniger als 600 Millimeter im Jahr. Charakteristisch sind tagelange schwere Regenfälle mit mehr als 400 Millimetern pro Tag, wahre Sintfluten, die zu Hochwasserkatastrophen führen können. Dergleichen ereignet sich allerdings nur etwa alle fünfundzwanzig Jahre, ist aber geologisch sehr bedeutsam.

Im Winter kann es im Gebirge empfindlich kalt werden, ich habe im Aspromonte noch im Juli an geschützten Stellen Schnee angetroffen und den erstaunten Bauern an der Küste einen Eimer davon mitgebracht.

Ich werde zuerst von meinem Leben in Ligurien berichten, zehn Jahre, und darauf die ligurischen Bilder zeigen. Dann folgt meine Zeit in Kalabrien, zwanzig Jahre, danach kommen die kalabrischen Bilder. Den Schluß bildet ein kurzer Abriß der Zeit »danach«, auch wieder zwanzig Jahre, so dass insgesamt über fünfzig Jahre im anderen Italien berichtet wird.

The other Italy. Stories and pictures from Liguria and Calabria

The other Italy – what is it? What might it mean? If we are speaking of the »other Italy«, then how do you define the two Italies – the one and the »other«? I am not trying to impose a special classification on Italy or introduce a new nomenclature. Instead, I am talking about my personal sense of the two Italies; the Italy of the wonderful cities and priceless artistic treasures – which I admire and venerate tremendously, although I don't know it very well – and the rural Italy, far from the bustle of the cities. This is the Italy of the Apennines, with its remote villages, churches and monasteries, and with its farmers, charcoal burners, shepherds and fishermen – although these old professions are now dwindling away. I love this »other Italy« with all my heart. For more than fifty years, I have walked hundreds of kilometres in this »other Italy«, and driven thousands of kilometres. It would be inaccurate to say that I rambled through it – a rambler is interested in contemplating the landscape and seeking out its famed beauties and unique features. Whereas I travelled through the mountains and valleys as a geologist on a surveying trip, armed with a rock hammer and a map, binoculars and a magnifying glass, compass and altimeter. And this is a sure-fire way to get to know and love the land and its people in an almost intimate way that naturally creates an appreciation for the beauty and uniqueness of the landscape.

One has to remember Italy's geography. Italy (the Italian »boot«) is an elongated, mountainous peninsula stretched at an almost diagonal angle across the Mediterranean Sea, from the north-west to the south-east. It is almost 1000 kilometres long and generally about 200 kilometres in width, with variations. Sicily is at the southern tip of the »boot«, almost like a football about to be kicked.

At 7600 kilometres, Italy's coastline is the longest of any country in Europe. It is hardly surprising that *la bella Italia* is also a land of beaches – one that attracts hordes of tourists. The country also has the advantages of a Mediterranean climate.

Italy is bounded by the Tyrrhenian Sea to the west and the Adriatic Sea to the east. To the north, where the peninsula's curved mountain range blends into the Alps, is the Ligurian Sea, with Genoa in the vertex. Venice lies opposite to it, where the Po exits its flood plains and empties into the north Adriatic. In the south Adriatic, at the heel of the boot, Italy and Albania lie very close together, only a few kilometres apart, because here the Adriatic narrows to the Straits of Otranto, before widening again as it meets the Ionian See, which lies between the foot of the »boot« and Greece.

Italy is divided into 20 regions. Liguria and Calabria – the two regions we are dealing with here – are very easy to locate. The narrow, elongated, mountainous coastal region of Liguria (one of Italy's smallest regions) is coextensive with the sea of the same name, running from Ventimiglia and Savona near the French border in the west past Genoa in the centre to La Spezia to the east, where it comes up against the Apuanian Alps and Tuscany.

The region is neatly and sensibly divided in two, with Genoa as the dividing point. The right-hand, eastern part, where the sun rises in the morning, is the Riviera di Levante, and the western, left-hand part, where the sun sinks in the evening, is the Riviera di Ponente. As a result, there are two places on the Ligurian coast named Sestri – Sestri Ponente to the west and Sestri Levante to the east of Genoa.

Liguria's land border, to the north, runs approximately along the Apennine watershed – although it deviates from this line too many times for me to describe in detail. There is one exception: the central Ligurian province of Genoa extends north, far beyond the watershed. In the past, it extended even further north – hence the many place names that include the element *ligure*: Cantalupo Ligure, Rocchetta Ligure. One part of Liguria – Monte Carmo, 1640 metres high and one of the highest mountains in the area – approaches within a few kilometres of the famous triple junction where the large regions of Piemont, Lombardy and Emilia Romagna touch. I spent many years working here – and the reader will understand that I had trouble explaining to the uninitiated exactly where I worked. I will continue to use the name »Liguria« for an area that also includes large tracts of Piemont and smaller tracts of Lombardy (as Lombardy happens to thrust a broad wedge southwards through this area).

Now we come to Calabria, which is, quite simply, the »foot« of the Italian »boot«. To the left, on the instep, is the Tyrrhenian Sea, and to the right, on the ticklish sole, is the Ionian Sea. Reggio di Calabria, the capital, lies on the Straits of Messina, with a view of neighbouring Sicily and the frequently snow-covered Mount Etna.

Calabria is dominated by three mountain massifs: the Pollino mountains to the north, the Serre and the Sila in the middle and the dark mountains of the Aspromonte – a massif crowned by Montalto, 1955 metres high – to the south. Italy's »big toe« is only 50 kilometres wide.

The Ionian flank of the southern part of Calabria – the area we are discussing here – reaches from the southernmost point of the Italian mainland at Melito di Porto Salvo to Monasterace Marina. This strip of land is about 100 kilometres long and (measuring from the watershed) about 20 kilometres wide. The climate down here can vary considerably. In summer, this strip of coast is hot and dry, and in the spring and autumn it rains – the area receives just under 600 millimetres a year. The area frequently experiences days of heavy rainfall, receiving more than 400 millimetres in a day – real deluges that can create disastrous flash flooding. This only happens about once every twenty-five years, but it is a major factor in the area's geology.

In winter, it can be uncomfortably cold in the mountains. I have encountered sheltered patches of snow in Aspromonte in July, and brought back a bucket of it to astonish the farmers on the coast.

First I will give an account of the ten years I spent in Liguria, and then I will show the pictures from Liguria. This will be followed by the twenty years I spent in Calabria, and the pictures of Calabria. I will finish with a brief outline of my life after these experiences – again, twenty years. In total, I will be telling you about fifty years in »the other Italy«.

My Italian period – my time spent with »the other Ita-ly« –, began on Monday the 18th of May 1959 in Ca-sella, a sleepy village in the mountains north of Genoa. I arrived in Casella at six in the morning, having trav-elled all night on an old and unreliable motorbike. I was so tired that I turned into the rear entrance of the first hotel I came to and asked for a basic room. When I finally saw the hotel's front from the charming *piaz-zetta*, I was horrified – I had chosen the best hotel in town, the well-appointed former residence of the Fieschi, a formerly flourishing and widespread ducal family who, as the title suggests, appear in Schiller's tragedy *Fiesco*. The staff of the hotel, however, were charming, giving me the cheapest room and later find-ing me lodgings with a cobbler in the village. I became known as »quello colla sciarpa rossa«, »the man with the red scarf«.

I was sent to this wonderful highland landscape by my Berlin professor, to write my diploma work on the »Ligurian crest« – a structure so named by a famous German geologist in 1927, which later turned out to be non-existent. Socially speaking, Casella was a serendipitous choice. Some citizens of Genoa had houses here, and lived in them in the summer – some-times for a few weeks, sometimes just for the week-end. This brought young people into the village, and I was quickly accepted into a clique. Everyone good-naturedly made fun of my bad Italian – which, in the circumstances, soon improved. But I only had time to socialise in the evening and perhaps on Sundays, while my days were filled with arduous surveying trips that often extended into the weekends. I wanted to finish as quickly as possible, because I was short of money and living on a small tutor's salary. At this time, students had to pay for their own field trips and study time abroad. When I became dean in 1970, I intro-duced the »geo title« into the university's budget, a measure which helped to finance this part of the stu-dents' education – a system envied by many other universities. This no longer exists.

All the same, I enjoyed my Spartan life in Casella. We often went to dances in the surrounding villages or to the cinema at Busalla. Once we saw a film about a miscarriage of justice in America – the desperate »non voglio morire!« of the woman sentenced to death will stay with me forever. At the time, there were no dis-cos. I introduced my Italian friends to a new word for »vomit«, because sitting in the back of a car on the winding roads always made me feel ill, leading me to ask the drivers to go slower and saying that otherwise »I would have to break«, which translates as »devo rompere«. »Rompere« only means »break« – not »vom-it«, which is »vomitare«, but it tickled my friends' sense of humour, and they referred to it as »rompere« from henceforth.

As my old motorbike, a NSU 125 ZBD, had barely survived the journey from Berlin to Casella, I used a pushbike while I was there and saved the motorbike for the return journey. Over five months, I surveyed 20 square kilometres. The stratigraphic sequence was very simple, but the tectonics were intensive, creating complex structures. The strata lay in massive folds, hundreds of metres high. At 7 am on Monday the 2nd of November 1959, after driving all night, I finally arrived in Berlin – at the end of four long stages of driving.

Today, Casella is a lifeless remnant, virtually a sub-urb of Genoa, and has lost all its charm. My Parco

Hotel Mario in the former Fieschi residence has been removed to make way for a bank, my friends from for-mer days have moved away or lost touch and the old-er ones among them are dead. The green meadows or *prati* that once hemmed in Casella on the side facing the Scrivia river have vanished, replaced by a depot belonging to the Standa department store business.

Giulia's parents kept the tobacco shop, and her mother kept close tabs on her. I wasn't allowed near her – except to take her to the cinema. So we went to the cinema – and then went off on our own. I think the film was *The Maltese Falcon*. We kissed in the green *prati* and were back in the cinema in time for the end of the film. Afterwards, I took her back, safe and sound, to the *tabaccheria*. I lost contact with Giulia a few years ago, when she sold the tobacco shop.

In August 1960, I returned to the Apennines to start studying the terrain for my dissertation. The subject was the border between the Alps and the Apennines, which can be observed only in a very narrow area – from Genoa to the north to beneath the young Po plain sediments. This area is only about 17 square kilo-metres in size, but has a highly differentiated strata arrangement and highly complex tectonics. It took me over a year of field work to survey it. I took my doctor-al examination in the spring of 1962. In the years from 1960 and 1961, I was based in Molini di Fraconalto, on the road from Voltaggio to Genoa and to the north and below the Bocchetta Pass. This area is on the often fog-shrouded watershed between the Tyrrhenian Sea and the Po plain – and the Adriatic beyond. Compared to Molini, Casella was a pulsing metropolis. In Italian, small villages are, quite aptly, referred to as *tre case*, *un forno*, three houses and a baker's oven. I never saw an oven, but there was an old smithy with a hea-vy hammer driven by water power. Molini was also the home of a »real« geologist, who showed me a tiny trib-utary valley containing valuable fossils that I would never have found for myself. He has been dead for several years now. Three years ago I visited his widow, now an elderly lady who uses a wheelchair, and we talked about *tempi passati*.

Molini had a *trattoria* with three rooms, one of which was allotted to me. The family who kept the restaurant treated me as a son. Whenever they ate *vitello tonna-to* – a favourite of mine – a portion was saved for me until I returned in the evening. I used to do my wash-ing in the stream by the road, encouraged by admiring farmers' wives who clearly wished their husbands would follow my example. The toilets and general hygiene were negligible, and when I was out and about in the field I generally made my own arrange-ments.

But one thing Molini held plenty of was friends – of both sexes. I even got to take my host family's young relative Lilli to the Gavi fortress on my motor scooter (now a Zündapp Bella). We got to know each other during the trip. At the time a large oil pipeline from Genoa to the Po plains was being built in the Molini valley, and I made friends with the pipeline engi-neers lodging in Molini, playing many hard-fought and instructive games of Italian billiards with them in the evenings. Thinking about it, over those three years I became an Italian. At least, that was how I felt – and it was a feeling I liked.

After being awarded my doctorate, I was fortunate enough to get a post as an assistant, paid by the

abendlichen Kämpfen das italienische Billard beibrachten. Wenn man es recht betrachtet, war ich in diesen drei Jahren zum Italiener geworden, ich fühlte mich wenigstens so und genoß es.

Nach der Promotion hatte ich das Glück, eine von der deutschen Forschungsgemeinschaft finanzierte Assistentenstelle zu bekommen, was mir zum einen ermöglichte, eine Familie zu gründen, zum anderen aber mit der Aufgabe verbunden war, sich um eine Habilitation zu bemühen. Inzwischen war ich so italienisiert und italienverwoben, daß für mich auch weiterhin nur Italien als Arbeitsgebiet in Frage kam. Einige Monate des Tastens und Suchens verstrichen, bis mir plötzlich einfiel, daß nördlich der Gebiete um Casella und Molini, also zum Rande der Poebene hin, ein für uns riesiges Problem darauf wartete, gelöst zu werden. Es ging um eine mächtige Schichtenfolge aus dem Tertiär, also eine vergleichsweise junge Formation von höchstens 60 Millionen Jahren, in der sich die späte Entwicklung des Apenningebirges exakt widerspiegelt. Ich suchte mir ein Typgebiet aus, das etwa von Voltaggio bis nach Varzi im Staffora-Tal reicht, 40 Kilometer lang und 20 Kilometer breit. Es umfaßt damit etwa 800 Quadratkilometer und wurde im Maßstab 1:25 000 fünf Jahre lang kartiert, natürlich nur in den Semesterferien.

Meine Basis war damals das Auto, in dem ich oft schlief, weil sich der weite Nachhauseweg nicht lohnte, oder die Albergo Mercato im idyllischen Sebastiano Curone, auch dieses Haus gibt es schon lange nicht mehr. Zu Abend gegessen wurde in einer der *trattorie*, die man damals zuweilen noch in den kleinen Dörfern finden konnte, natürlich ohne Unterkunft für die Nacht. Ich hatte an den Flüßchen und in den Kastanienwäldern mehrere Schlafplätze ausgeguckt und jeweils an sorgfältig ausprobierten Stellen zwei Steine als Markierung gelegt, gegen die man abends nach dem Essen nur mit den Vorderrädern fahren mußte, das Auto stand dann gerade, eine Voraussetzung für bequemes Schlafen. Ich wusch mich in den Bächen, das Wasser für den Frühstückstee wurde auf dem Benzinkocher erhitzt. Dieses Vagabundenleben verhinderte natürlich die längeren Freundschaften früherer Tage. Die Einzelgehöfte, die ich antraf, waren oft bereits verlassen, kein Rauch stieg auf, keine Hühner gackerten, kein Hund bellte. In den Dörfern stehen viele Häuser leer, viele sind aber auch als Landhäuser für die Städter hergerichtet, die jetzt nicht mehr aus Genua, sondern überwiegend aus Mailand kommen.

In Sebastiano Curone, einem der schönsten und verschwiegensten Orte, die ich kenne – hier habe ich, wie in der ganzen Gegend, noch nie einen deutschen oder ausländischen Touristen gesehen –, freundete ich mich mit Carlo, dem Pächter der großen Bar gegenüber der Arzola-Brücke an, der mir später sehr behilflich war, meine Diplomanden unterzubringen. Noch heute, wenn wir nach Rocchetta fahren, wovon später noch die Rede sein wird, nehmen wir nicht den Weg über die Autobahn, sondern biegen in Tortona ab, um über das ruhige, friedliche Gebirge nach Sebastiano Curone zu gelangen, wo wir in Carlos Bar einen letzten Stopp einlegen, den letzten der Herreise und den ersten im Lande, und mit zwei großen Begrüßunsgrappas bewirtet werden, ein Willkommensgruß, natürlich gratis und franco.

In die Albergo Mercato in Sebastiano Curone hatte ich sogar einmal mein Cello aus Berlin mitgenommen, um nicht ganz aus der Übung zu kommen. Im März, in dem ungeheizten, eiskalten Zimmer, das mir die Signora zum

Üben überlassen hatte, brauchte ich immer eine kleine Ewigkeit, um auf dem ebenfalls eiskalten Instrument warm zu werden. Vor der Albergo Mercato, der Name verrät es, gab es damals noch einen Viehmarkt mit zahllosen Eisengeländern und einem großen, grünen Pissoir aus kunstvoll gestanztem Eisenblech. Seinerzeit war der Markt ein Ort des Lebens, oder auch des nahen Todes für die Schlachttiere, heute ist er ein nichtssagender Parkplatz.

Mein Bericht über das andere Italien wäre aber unvollständig, wenn ich nicht auch die Kirchen und Klöster erwähnte, die es hier in Ligurien durchaus gibt. Ich meine natürlich nur die alten, romanischen Kirchen und beginne mit San Giacomo in Gavi, dem berühmten Weinort, erstmalig erwähnt im Jahre 1172. Sie besitzt eine wunderschöne, ganz unveränderte Westfassade mit einem reichen Tympanon, das, recht naiv, eine Abendmahlsszene darstellt. Im Inneren überraschen große Kapitelle mit üppigen Tierszenen. Die Fenster der Seitenschiffe sind allerdings ziemlich rücksichtslos barockisiert. Ich habe die Kirche innen und außen oft photographiert. Freundliche Leute ließen mich sogar auf ihren gegenüberliegenden Balkon im ersten Stock, weil die Fassade sonst in der engen Straße nicht zu photographieren gewesen wäre.

Nähert man sich unserem Gebiet von Tortona aus, so muß man durch Viguzzolo fahren und kommt an einer Backsteinkirche vorbei, der Pieve di Santa Maria. Das Wort *pieve* bedeutet soviel wie Pfarre oder kleine Kirche, es leitet sich aus dem lateinischen *plebs* ab, dem einfachen Volk. Die Westfassade der romanischen Kirche ist kunstvoll durch Lisenen gegliedert, das Innere eine eindrucksvolle Halle mit weiten Backsteinbögen zu den Seitenschiffen hin, auch eine Krypta fehlt nicht. Den Schlüssel gibt es beim Bürgermeister, man muß allerdings etwas insistieren, weil der Schlüssel jedesmal bei einem anderen Angestellten in einer anderen Pappschachtel aufbewahrt wird. Man bekommt ihn aber anstandslos auf Treu und Glauben ausgehändigt.

Etwas weiter südlich führt diese Straße an Volpedo vorbei, das eine ganz ähnlich gebaute *pieve* besitzt, die im 10. Jahrhundert erstmals erwähnt wird. Diese Kirche wurde im 15./16. Jahrhundert fast völlig ausgemalt, die Fresken sind überwiegend gut erhalten, die Malerschule ist bekannt. Hier wurde ich an die Associacia Pellizza verwiesen. Giuseppe Pellizza war ein bedeutender Maler des italienischen Realismus, er starb 1907, eine Kopie seines großen Hauptwerkes ziert die Einfahrt von Volpedo am Straßenrand. Dieses Institut hütet also den Kirchenschlüssel, photographieren darf man unbegrenzt.

Einsam in den Bergen des Vorapennin, mit prächtigem Blick in die nahe Poebene, liegt, im Norden von Varzi, das Kloster Sant'Alberto di Butrio, ein lebendiges Kloster, in dem noch heute einige Mönche leben. Kirche und Kloster sind vollständig erhalten, ebenso die Ausmalung mit zahllosen Fresken von 1484. Besonders berührt mich immer die Darstellung von Sigismondo, Sigismund von Luxemburg, Kurfürst von Brandenburg, 1378 bis 1388 und römisch-deutscher Kaiser von 1433 bis zu seinem Tod im Jahr 1437, er soll das Kloster besucht haben, ebenso wie Dante und Barbarossa, heißt es. Ich photographiere die Fresken immer wieder, und die Mönche lassen sich nicht stören.

Deutsche Forschungsgemeinschaft. I could now start a family, but this also meant that I had to work towards my habilitation. By then, I had become so Italianate and bewitched by Italy that I could not possibly work anywhere other than Italy. Several months of search and inquiry went by. Then I suddenly realised that there was a huge problem waiting to be solved on the edge of the Po plain, to the north of the Casella and Molini areas. A huge stratigraphic sequence from the Tertiary period – a comparatively recent formation 60 million years old – exactly reflects the late development of the Apennines. I found myself a typical area that stretched from Voltaggio to Varzi in the Staffora valley, 40 kilometres long and 20 kilometres wide. This area comprised about 800 square kilometres, and took five years to survey on a scale of 1:25 000 – in the academic holidays, of course.

As home was too far away to be worth the drive, my base was the car – in which I often slept – or the Albergo Mercato in the idyllic Sebastiano Curone (another building that has been gone for several years). In the evenings, I ate at one of the *trattorie* you used to find in the small villages in those days – where, of course, one could not stay the night. I would spy out several sleeping places on the little river and in the chestnut woods and marked each carefully checked site with two stones. Each evening, after eating, I would bump my front wheels up against these stones so that the car would stay straight, making it tolerably comfortable to sleep with. I washed in the streams, and heated the water for my breakfast tea on my petrol stove. This vagabond life naturally made it harder to make friendships as I had done in former days. The isolated farmsteads I came across were often abandoned, with no plume of smoke, no gabbling chickens, no barking dogs. Many houses in the villages stood empty, and several were now »houses in the country« for city dwellers – who now came from Milan rather than Genoa.

In Sebastiano Curone, one of the most beautiful and secluded places I know – I never saw a German or, indeed, foreign tourist here or anywhere in the area –, I got to know Carlo, lessee of the large bar opposite the Arzola bridge, who later helped me to find lodgings for my diploma students. Even today, whenever we drive to Rocchetta – a place I will speak about later – we avoid taking the motorway, and turn off at Tortona to take in the quiet, peaceful mountains beyond Sebastiano Curone – making a last stop in Carlo's bar to be served two large grappas by way of welcome – gratis, of course.

Once I even took the cello I kept in Berlin to Albergo Mercato, so as to avoid getting totally out of practice. In March, in the unheated, ice-cold room, where the Signora permitted me to practice, it took forever for me and my instrument to get warmed up. At the time Albergo Mercato really did have a large cattle market, with many iron rails and a large green pissoir made of elaborately stamped sheet iron. In its day, the market was a place full of life (except for the animals about to be slaughtered). Today, it is a nondescript car park.

My report on the »other Italy« would be incomplete without Liguria's many churches and monasteries. Here I am speaking of the old Romanesque churches. Firstly, there is the church San Giacomo in Gavi, the famous wine-growing region first recorded in the year 1172. It has a wonderful west façade (which survives unchanged) and an elaborate tympanum with a naive Eucharist scene. In the interior, the pillar's capitals are surprisingly large, with impressive animal scenes. Unfortunately, the windows of the side aisles were remodelled rather insensitively during the Baroque period. I have photographs of both the inside and outside of this church. Some kind people even let me photograph it from their balcony on their first storey, because it was not possible to properly photograph the façade from the narrow street.

Approaching this area from Tortona, you drive past Viguzzolo and pass a brick church, the Pieve di Santa Maria. The word *pieve* means parish or small church, and comes from the Latin word plebs – meaning »common people«. The west façade of the Roman church is artistically subdivided by pilaster strips, and the interior is an impressive hall, with broad brick arches where it meets the side aisles. There is also a crypt. The key could be obtained from the mayor – some persistence was required, because the key was always being kept by a different functionary in a different cardboard box. Still, it was always handed over graciously and trustfully.

A little to the south, the road bypasses Volpedo, where there is another *pieve* very similar in construction. It is first recorded in the 10th century. This church was almost completely painted in the 15th or 16th century, and most of the frescoes have been preserved. We know which school of painting created these – I was referred to the Associazione Pellizza. Giuseppe Pellizza was a significant Italian Realist painter who died in 1907. A copy of his major masterpiece decorates the entrance to Volpedo, by the side of the road. This institute looks after the key to the church, and photographing is allowed.

The monastery of Sant'Alberto di Butrio is in an isolated location in the foothills of the Apennines to the north of Varzi, with a fine view of the neighbouring Po plains. It is a living monastery, and some monks are still in residence here. The church and monastery are completely preserved, as are numerous frescoes from 1484. I was always particularly attracted to the picture of Sigismondo, Sigismund von Luxemburg, Kurfürst of Brandenburg from 1378 to 1388 and Roman-German Emperor from 1433 until his death in 1437, who, like Dante and Barbarossa, is said to have visited the monastery. I photographed the frescoes several times, with the monks taking it all in their stride.

Avi

Die Bergzüge des Apennin, die aus der italienischen Halbinsel heraufziehen und um die nördliche Tyrrhenis herum in die Seealpen und den Westalpenbogen münden, haben im Hinterland von Genua eine Breite von nur 50 Kilometern. Dieses Hinterland ist im Nordwesten hügelig und reich besiedelt. Im Nordosten ist es ein Gebirge, manchmal bis weit über 1000 Meter hoch, dicht bewaldet mit Kastaniengestrüpp, dem *bosco*, und kaum besiedelt. Schon Genua, die umtriebige Hafenstadt, hat wenig Platz und wird von den Küstenbergen beinahe ins Meer gedrängt. Im Landesinneren ist die Enge noch spürbarer. Die Dörfer sind klein, die Hänge hoch hinauf terrassiert, um Raum für die kärglichen Äcker zu gewinnen, die hinteren Täler wurden erst nach dem Zweiten Weltkrieg durch Straßen erschlossen. Höchster Berg ist der Monte Antola mit fast 1600 Metern. Er schickt enge Täler in alle Himmelsrichtungen, mit steilen Hängen und oft recht wilden Flüssen. Einer davon ist der Borbera.

Ich kenne die Gegend seit fast fünfzig Jahren und habe dort viele Freunde gewonnen, allen voran die Familie Parini in dem kleinen Hotel an der Brücke von Rocchetta, Großeltern, Eltern und Enkel. Vor wenigen Jahren ist der »Nonno« gestorben, Antonios Großvater und Manuelas Vater, der noch viele Partisanengeschichten vom Ende des Krieges zu erzählen wußte, in einem kaum verständlichen Genueser Dialekt.

Bei Rocchetta Ligure, nahe dem Dreiländereck von Ligurien, Piemont und Lombardei, nur etwa 35 Kilometer nördlich von Genua, trifft der Borbera auf den geradezu dramatischen Bergzug des Costone della Ripa. Der Borbera und sein Zufluß, der Sisola – im Italienischen sind die Flußnamen männlich – liegen hier etwa 400 Meter hoch. Sie begleiten die gewaltige, von Süden nach Norden gerichtete und fast schnurgerade Felswand auf sechs Kilometern Länge, die Wand mißt gut 400 Meter in der Höhe. Wer sie zum ersten Mal sieht, staunt und hält solch eine trotzige Mauer in der friedfertigen Umgebung für undenkbar. Aber sie steht da, seit Urzeiten, nur ein einziger Saumpfad führt im Süden quer hindurch, bei Pagliaro Superiore. Die Wand, aus eintönigen Kalkkonglomeraten aufgeführt, bietet fast nur blanke Felswände, in den Furchen und Nischen siedelt kärgliches Gebüsch. Vormittags sind ihre steilen Schluchten von grellem Sonnenlicht ausgeleuchtet, nachmittags versinkt sie in finsterem, abweisendem Schatten.

Der Bergzug des Costone della Ripa, ich möchte ihn der Einfachheit halber nur Borbera-Zug nennen, ist so unwegsam und menschenleer, daß seine Höhen selten Namen tragen, nur zwei von sieben tun dies, der Monte Cravasana mit 870 Metern und Il Poggio mit 853 Metern. Ganz im Süden erhebt sich der Burgberg von Roccaforte Ligure mit 859 Metern und den Resten eines Castello Malaspina aus dem 11. Jahrhundert. Die Malaspina sind eine weit gefächerte Adelsfamilie langobardischen Ursprungs. Nach vielen Wechseln der Besitzer übernahm die ebenso berühmte Familie Spinola die Burg, bis dann, 1797, auf ein Dekret Napoleons hin alle imperialen Großgrundbesitze abgeschafft wurden. Der gesamte Borbera-Zug ist unbewohnt, unbesiedelt, mit einer winzigen Ausnahme: Avi.

»Avi«, nur drei Buchstaben, das Minimum fast eines Wortes, aber ein guter Klang, das offene, einladende »A«, das witzige, etwas kindliche »i« zum Schluß und als Balance dazwischen das warme »v«, wie ein »w« gesprochen. Avi. Aber so schön das Wort klingen mag, so leicht es sich sprechen läßt, so steht es doch für große Armut, Entbehrungen, härteste Arbeit, tiefste Einsamkeit und ständige Not. Avi wurde Ende der 1950er Jahre von seinen wenigen Bewohnern für immer verlassen, etwa 20 sollen es gewesen sein, seitdem zerfällt es.

Antonio hatte mir im Januar eine Mail geschickt und gefragt, ob ich nicht Photos von Avi besäße, ich sei doch einmal dort gewesen. Eine Familie Tegaldo aus Urugay habe sich bei ihm erkundigt, sie stamme aus Avi. Leider habe ich keine Photos von Avi, aber um so mehr Erinnerung. C., meine Frau, und ich beschlossen, Ostern mit Antonio nach Avi aufzubrechen und uns anzusehen, was davon noch übrig ist. Der Weg dorthin ist lang und anstrengend. Antonio hatte einen Freund engagiert, Nicola, der einen winzigen, aber ungewöhnlich leistungsfähigen Geländewagen besitzt, ein *fuoristrada*, ein Auto »außerhalb der Straße«, ein japanisches oder koreanisches Fabrikat. Wir fuhren zuerst mit Antonio zur Parrocchia von Roccaforte, die mir seit vielen Jahren vertraut ist. Der Priester lebt leider nicht mehr. Als ich in den späten 1980er Jahren einmal an seinem Haus vorbeikam, ich wollte mich wegen eines geologischen Problems noch einmal vor Ort vergewissern, bat er mich auf einen Wein hinein, und wir hielten einen langen Schwatz. Der unwegsame Borbera-Zug, erzählte er, sei gegen Ende des Zweiten Weltkriegs ein Rückzugsgebiet für die Partisanen der Gegend gewesen. Die gegenwärtige Straße sei weniger steil als die ursprüngliche, die von den Leuten aus Roccaforte umgebaut worden war, um den Transport der schweren, von Ochsen gezogenen Holzlasten zu erleichtern. Die 1944 begonnenen Arbeiten seien von einer »Säuberungsaktion« der Deutschen unterbrochen worden, als sich dort junge Partisanen versteckt hielten, die man jedoch rechtzeitig gewarnt habe. Er führte mich in einen Stall und zeigte mir eine blecherne Viehtränke, die sich die Bauern aus der Tragfläche eines in der Gegend abgestürzten deutschen Flugzeugs gebaut hatten.

Nicola ließ etwas auf sich warten, schließlich aber kam er, und wir stiegen um. Der Wagen ruckelte gewaltig, obwohl Nicola nie schneller als im Schrittempo fuhr. Über drei Kilometer lang ging das so, immer sozusagen die Felswand entlang. Die Straße war recht schmal, jedoch gerade noch befahrbar. Ich saß auf der steil abschüssigen Talseite, und mir war etwas flau zumute, einen Absturz hätte keiner überlebt. Irgendwann erreichten wir das Ende des befahrbaren Weges und parkten den Wagen am Abzweig des Fußwegs nach Avi.

Der Weg war steil und mühsam, in engen Windungen führte er bergab. Früher, als die Herde und Öfen von Mailand und Genua noch mit dem Brennholz dieser Kastanienwälder beheizt wurden, pflegten die Bauern die Wege und hielten sie von Gestrüpp und herabfallenden Ästen frei, das war sogar zu Beginn der 1960er Jahre noch so, als ich dort arbeitete. Heute sind die *sentieri* und *mulattiere* zugewachsen, so daß man sie kaum erkennen kann. Hoch liegt das Kastanienlaub, und der Tritt ist unsicher. Plötzlich erblickten wir durch das Gebüsch unter uns Avi, ein einzelnes, ziemlich großes Haus mit rotem Ziegeldach. Der Pfad endete an einem Rinnsal. Dahinter erhob sich eine schräge Felsrampe, auf der wir nicht die Andeutung eines Weges ausmachen konnten. Hier mußte einmal ein Holzsteg gewesen sein, der aber nun völlig verschwunden war. Einzeln überstiegen wir die schwierige Stelle, bisweilen auf allen Vieren.

Dann waren wir am Haus. Es maß etwa acht Meter im Geviert, mit einem größeren und einem kleineren Raum. Die darüber liegende Decke und das Dach waren halb

Avi

The mountain ranges of the Apennines, that rise from the Italian peninsula and merge into the Maritime Alps and the bow of the Western Alps in the north Tyrrhenian area, are only about 50 kilometres wide where they pass through the hinterlands of Genoa. In the northwest, this hinterland is hilly and densely populated. The north-eastern region is mountainous (sometimes reaching much more than 1000 metres in height), and densely covered with chestnut woodland, or *bosco*, and sparsely populated. Genoa, the bustling harbour city, has limited space, being almost pushed into the sea by the coastal mountains. In the interior, there is even less space. The villages are small, and the slopes are terraced into sparse fields to a considerable height. Roads were only built to the most remote valleys after the Second World War. The highest mountain is the Monte Antola, which is almost 1600 metres high. From this mountain, narrow valleys branch out in all directions, with steep slopes and many wild regions. Borbera is one of these.

I have known the area for almost fifty years, during which time I have made many friends there, the foremost of whom were the Parini family – grandparents, parents and grandchildren – in the small hotel at the Rocchetta bridge. A few years ago, the old »Nonno« (Antonio's grandfather and Manuela's father) died. He always had to tell a lot of stories about partisans from the end of the war (in his almost indecipherable Genoese accent).

Borbera meets the dramatic Costone della Ripa mountain range at Rocchetta Ligure, close to the point where Liguria, Piemont and Lombardy meet and about 35 kilometres north of Genoa. The Borbera and its tributary, the Sisola – masculine, like all Italian river names – flow about 400 metres above sea level here. They run six kilometres from south to north along the massive and almost arrowstraight rock wall, which is at least 400 metres in height. Anyone seeing it for the first time cannot believe that such a massive, defiant wall in such peaceable surroundings can possibly be natural. But it has been standing there since time immemorial, with a single bridle path leading across it to the south, transversely, at Pagliaro Superiore. This uniform wall of limestone conglomerates presents a blank rock face almost everywhere, with sparse bushes clinging in the furrows and niches. Before noon, its steep gullies are filled with bright sunlight, and in the afternoon they descend into dark, forbidding shadows.

The Costone della Ripa mountain chain – which I will call the Borbera chain for simplicity's sake – is so impassable and empty of human life that its peaks rarely have names: out of the seven of them, two – Monte Cravasana, which is 870 metres high, and Il Poggio which is 853 metres high – are named. To the far south is the mountain fortress of Roccaforte Ligure, which is 859 metres high and contains the ruins of Castello Malaspina from the 11th century. The Malaspina family is a well-represented aristocratic family, originally from Lombardy. After changing owners several times, this castle came into the possession of the equally famous Spinola family until 1797, when Napoleon decreed that all major imperial estates were to be dissolved. The Borbera range is unpopulated and unsettled, with one exception: Avi.

»Avi« is just three letters – almost the minimum for a word – but it has a good sound to it: the open, inviting »A« at the beginning, the humorous, slightly childlike »i« at the end and, in between, the warm »v«. Avi. But although the word is beautiful and rolls off the tongue, it stands for nothing but great poverty, privations, hard work, deep isolation and constant necessity. At the end of the 1950s, Avi's last inhabitants – about 20 people – departed forever. Since then, Avi has been left to decay.

In January, Antonio sent me a message asking me whether, since I had been there once, I had any pictures of Avi. A family named Tegaldo from Uruguay had enquired, saying that they came from Avi. Unfortunately I had no photos of Avi, but I did have plenty of memories. Together with my wife C., I decided to travel to Avi with Antonio to see what is left. The journey is long and arduous. Antonio enlisted the services of his friend Nicola, who owned a tiny but remarkably efficient off-road vehicle – a *fuoristrada* – made in Japan or Korea. First, we drove with Antonio to the parish of Roccaforte, which I knew of old. Sadly, the priest I knew in those days is now dead. In the 1980s, I passed by his house on a trip to recheck a geological problem on location. He invited me in for a cup of wine, and we chatted for some time. He told me that at the end of the Second World War the trackless Borbera range had been a stronghold of the local partisans. He also said that the original road had been much steeper than the present one, which had been built by the people of Roccaforte to facilitate the transport of heavy loads of wood drawn by oxen. Work on this road began in 1944, but was interrupted by a German »cleaning-up operation« directed at young partisans hiding in the area – who, however, were warned in time. He showed me a metal drinking trough for cattle in a stable built from the wings of a German aircraft that crashed in the area.

We had to wait for Nicola for some time. When he finally arrived, we changed vehicles. The vehicle jerked and pitched a good deal, although Nicola kept it to a walking pace. We drove three kilometres along the rock wall. The road was very narrow, but was still driveable – just. I was sitting close to the steeply receding side of the valley, which was rather unnerving – if we had fallen, we would have all died. Finally we could make no more progress in the car, so we parked it at the turn-off of the footpath to Avi.

The route was steep and arduous, winding downwards in tight meanders. Once upon a time, when stoves and ovens in Milan and Genoa were fuelled with firewood from these chestnut woods, the peasants used to look after the paths and keep them clear from undergrowth and falling branches. This was still the case at the beginning of the 1960s, when I worked there. Today, the *sentieri* and *mulattiere* are overgrown, and are almost unrecognisable. Thick layers of leaves of the chestnut trees cover the ground, and the footing is unsafe. Suddenly, through the bushes below us, we saw what was left of Avi – a single, rather big house with a red tiled roof. The path ends at a rill. Beyond this rose a slanted ramp of rock, on which we could see no trace of a path. There must have been a wooden staircase here once, but now there was no trace of it. We crossed this difficult stretch in single file, sometimes on all fours.

Then we arrived at the house. It measured about eight metres square, with one large room and one

pened. I could hardly believe my eyes. The »Nonno's« bony left hand, which had been lying on the edge of the table, wandered slowly but surely to the left, towards the beautiful woman, while, as I could clearly see from the angle of his tilted head, he kept a close eye on the other people seated at the table and the fingers of his right hand drummed nervously. His left hand, with its loose, rather too broad watch strap, moved towards the beautiful lady's hand. His hand touched hers, lifted and rested on hers for a second. No, it was less than a second – the beautiful young woman startled, withdrew her hand and turned towards the »Nonno« with a surprised and questioning air, while he gave her a beaming smile I had never seen from him before, and would never have believed possible. Another time, I asked Manuela about the beautiful woman, and found out that it was his granddaughter – Anna, the daughter of Manuela's brother. But that doesn't change anything about the story. I don't think a man ever gets too old to be interested in women.

On the 30th of December almost two years ago, I saw the »Nonno« quietly crying because of the death of his wife. He was stroking his little dog, which was sitting on his lap. It was an ugly smooth-coated mongrel spotted black-and-white like a Holstein milk cow, but he loved it. I never met the »Nonna«; she was several years older than the »Nonno«, and when I knew him she was 88 and aged. The »Nonna« had three names, each more beautiful than the last: Piera, Clorinda and Enrica. People called her Pierina and Enrichetta.

Marco's wedding to Pierina must have been wonderful. In 1937, Mussolini, the Duce, invited several Italian couples (among them Marco and Pierina) to Rome to be married, as part of the Fascists' well-known drive to promote marriage and child-bearing. This was Marco's only journey into the wider world – from Albera Ligure behind the mountains to Rome of the seven hills. A year later, Manuela – who told me all this – was born.

Yesterday evening, as we all waited patiently for the meal to arrive, the »Nonno« had looked at me with his big, grey eyes and said something I didn't understand because he nearly always spoke in dialect. Up here, Genoese dialect is still spoken, and it varies significantly even from village to village. This Genoan dialect sounds very French, with a lot of Ü sounds. The word for up is *sü*, not *su*. Twelve and thirteen, fourteen and fifteen, written phonetically, are *duse* and *träse*, *katorse* and *kingse*, as in French.

So, the »Nonno« said something, and I stood up, went over to him and laid my hand on his thin shoulder, the way everyone else did, and said loudly into his ear that today we had been to Valbrevenna, a wonderful mountain valley a little south of his Borbera and Carrega valley, that also leads to Monte Antola, the highest mountain of the whole Genoese massif. There are several remote mountain villages there, with the terracing almost effaced. Until the end of the Second World War, most of these were reachable only via the *mulattiere*, or mule trails – just like the Carrega valley. When I said »Valbrevenna«, I was astonished to discover that he did not even know this valley. The »Nonno« was one of those people who never left their own little mountain valley – with the exception of the visit to Mussolini in Rome.

Marco, the »Nonno«, was saying something about Campassi, just as he always had – a tiny mountain village right underneath the Monte Antola, and very close to Valbrevenna. A very narrow, endlessly long mountain road winds its way to Campassi. No-one lives there now. He talked about a broad cobbled road, and his bony hands traced the shapes of large imaginary spheres, a street with drains running across it every four metres to stop the rain from washing everything away. I could understand that much. Every evening, when we returned, he asked us where we had been, and he would always – regardless of our answer – end up talking about the cobblestones of Campassi. I watched my parents grow old, and I do have some idea of what happens to people as they get old.

Antonio told us he had been a *commerciante di bestiame* – a cattle trader – and that he used to know all the shepherds and farmers in the area, but his work does not appear to have taken him out of the valley. The »Nonno« had previously told me about the region's cattle-based wealth, continually interrupted by Antonio, who said, »Talk Italian, or he won't be able to understand you«, about mountain meadows black with sheep and goats, and the air full of birds. The »Nonno« still liked to go into the woods, where he knew all the paths, to collect chestnuts. He even rode a bicycle. Sometimes he forgot everything and came back to the house in his shirt. Then Antonio would take him back to the woods, where they would find his flat cap neatly hung on a branch, his jacket on a tree and a sack half-full of chestnuts, all forgotten.

The »Nonno« had become increasingly stubborn in his old age. Lately he had gone to visit his son, Manuela's brother, in Novi Ligure. Left unattended for half an hour, he went to the livestock market and bought a cavallino, a pony. No-one dared take it back. As if that wasn't enough, he also refused to allow the pony to be put in the large stable with Roberto's horses, where it could have been looked after every day. Instead, he put it in his own old stable in Cantalupo, where he looked after it in a rather haphazard way every day. Dreadful to him as it was, he disregarded even his brother's threat to send him to the *suore*, the sisters who kept the old people's home, if he didn't listen to Manuela. After all, he had proved that he was still a competent animal trader.

As time went by, Marco, the »Nonno«, talked less and less. When he did talk, he talked about times gone by. Occasionally, he would give a long monologue in unintelligibly dense dialect, loudly and insistently, initially listened to by those seated around him, but later talking to empty space as everyone went back to their own conversations. Sometimes he would fly into a fury over trifles, »si arrabbia per niente«, as Manuela said, but then he would be given something to drink and calm down. What a wonderful old age, in the bossom of his family and at the heart of everything going on in the house. I hope this life of his continues for many more years. Next Christmas, snow permitting, we would drive through the Bosco to Campassi and visit the place again. In the evening, we would have a real informed chat with the »Nonno« – perhaps about the thick cobbled road.

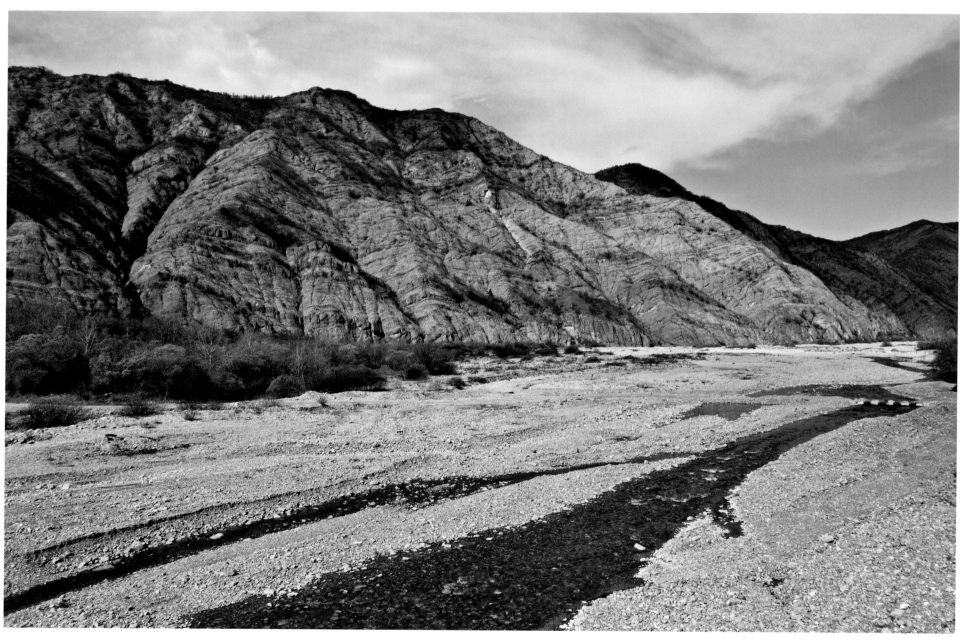

1. Die Konglomerate des Borbera-Zuges von der Borbera-Brücke bei Rocchetta Ligure aus gesehen.
2. Die hier etwa 400 m hohe Konglomerat-Wand des Borbera-Zuges bei Cantalupo Ligure.

1. The conglomerate rock of the Borbera chain, as seen from the Borbera bridge near Rocchetta Ligure.
2. The Borbera chain conglomerate wall near Cantalupo Ligure. At this point, it is about 400 m in height.

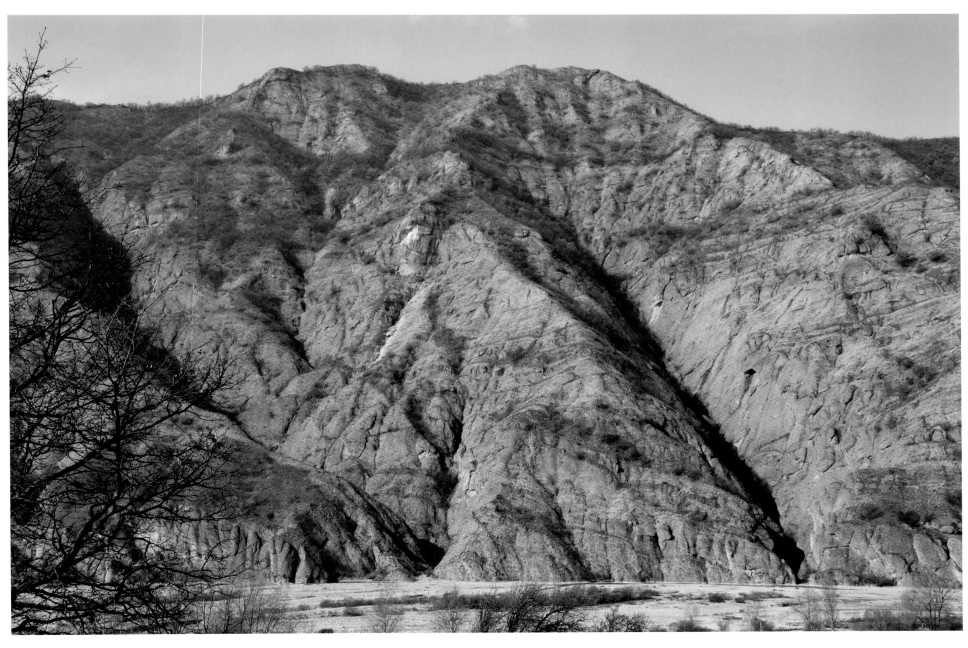

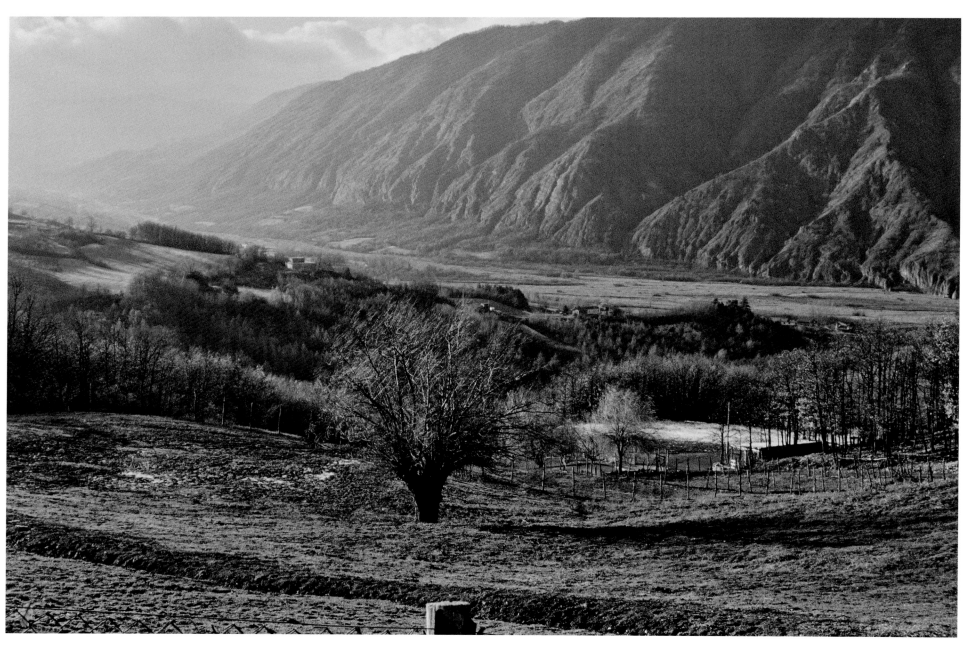

17, 18. Casa Manuele, ein verlassener Bauernhof zwischen Roccaforte Ligure und Grondona.

17, 18. Casa Manuele, an abandoned farm between Roccaforte Ligure and Grondona.

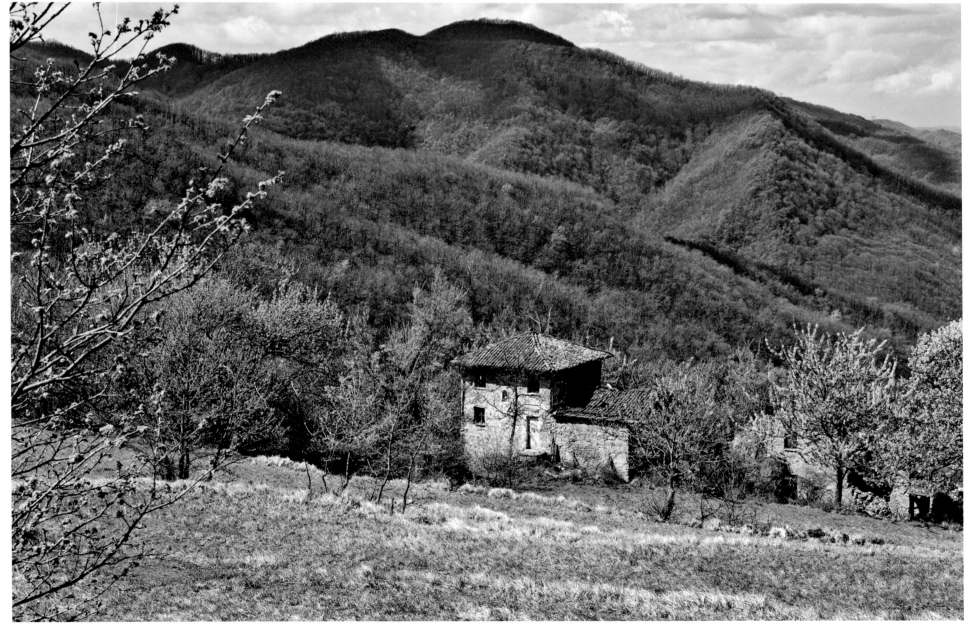

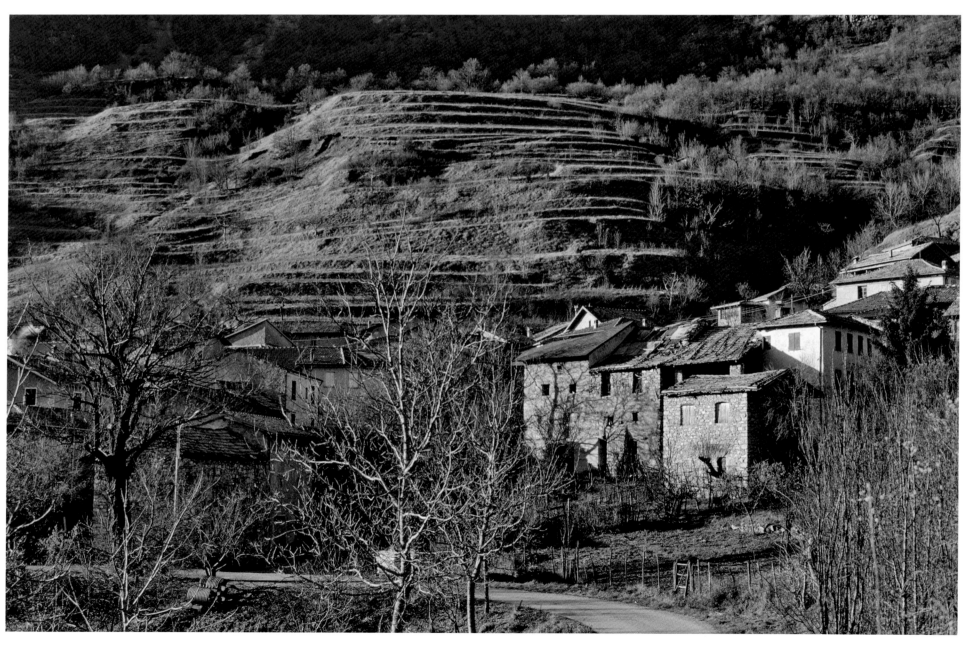

19. Terrassen über Gorreto südöstlich Cabella Ligure.
20. Restegassi südlich Sebastiano Curone.

19. The terraces above Gorreto, to the south-east of Cabella Ligure.
20. Restegassi, to the south of Sebastiano Curone.

35. Holzplatz bei Lemmi östlich Grondona. Dieses Brenn-
holz bildete seinerzeit eine wichtige Erwerbsquelle der Berg-
bauern.
36. Verfallener Schuppen mit Blechdach bei Montemanno
südlich Roccaforte Ligure.

35. A timber yard near Lemmi, to the east of Grondona.
At one time, firewood was an important source of reve-
nue for mountain farmers.
36. A derelict hut with a tin roof near Montemanno, to the
south of Roccaforte Ligure.

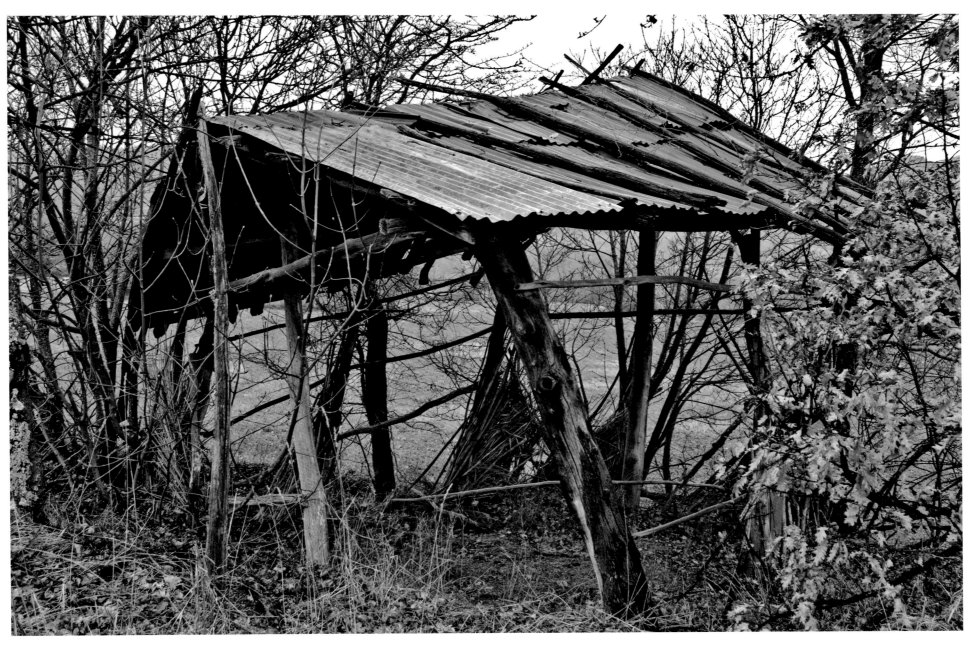

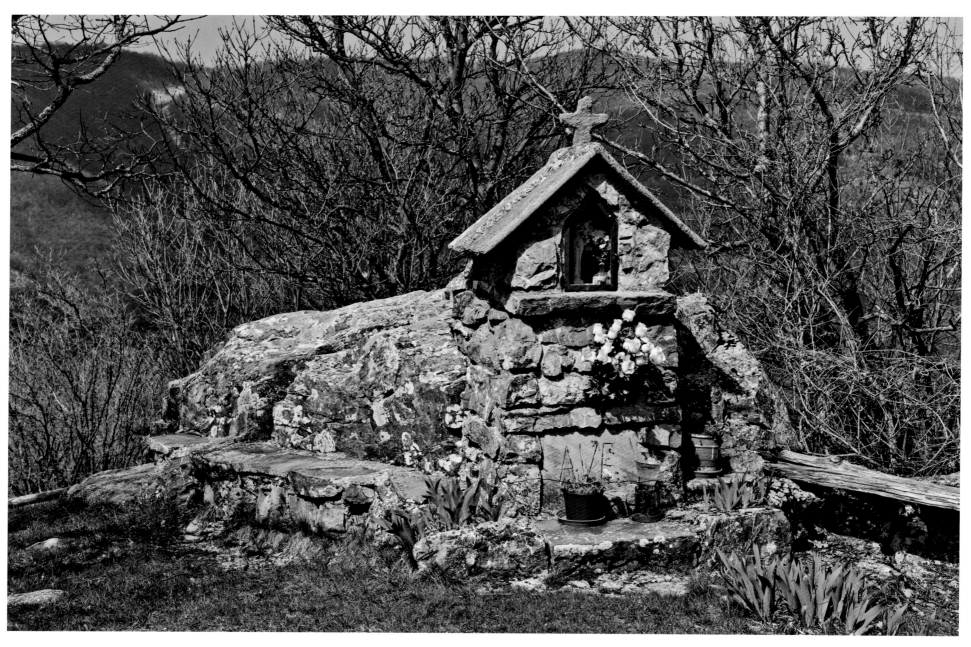

37. Tabernakel bei Dova Superiore südlich Cabella Ligure.
38. Eine Weg-Kapelle zwischen Costa Merlassino und Strappasese.

37. A tabernacle near Dova Superiore, to the south of Cabella Ligure.
38. A roadside chapel between Costa Merlassino and Strappasese.

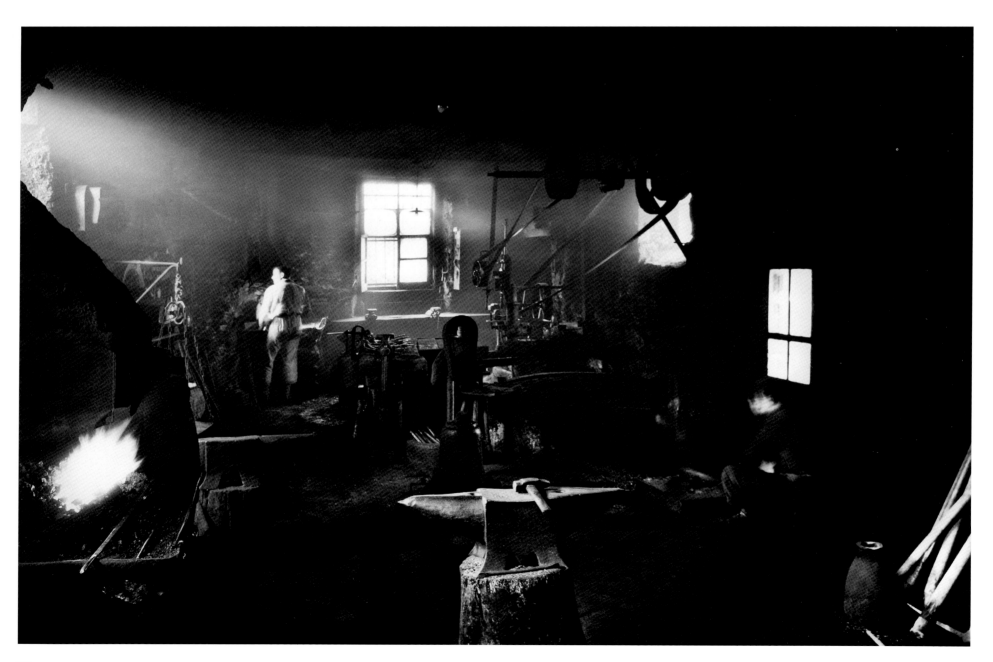

51. Das Kloster Sant'Alberto di Butrio. Fresko von 1484. Links Sant'Alberto mit Krummstab und Mitra, dann die heilige Apollonia mit Zange und Zahn, eine mit dem Ausreißen der Zähne gefolterte Märtyrerin. Dann Maria mit dem Kind und daneben die heilige Lucia, der die Augen ausgestochen wurden, auch sie trägt den Palmzweig der Märtyrerin. Ganz rechts dann der heilige Antonius, der Eremit mit dem T-Zeichen und der Pestglocke.
52. Das Kloster Sant'Alberto di Butrio. Der heilige Georg.

51. The monastery of Sant'Alberto di Butrio. A fresco dating from 1484. To the left is Sant'Alberto with his crook and mitre, followed by St. Apollonia with a pair of tongs and a tooth. She was a martyr, tortured by having her teeth torn out. Next comes Mary with her child, and St. Lucia, whose eyes were put out. She is also carrying the palm of a martyr. To the far right is St. Anthony the Hermit, with a T sign and plague bell.
52. The monastery of Sant'Alberto di Butrio. A figure of St. George.

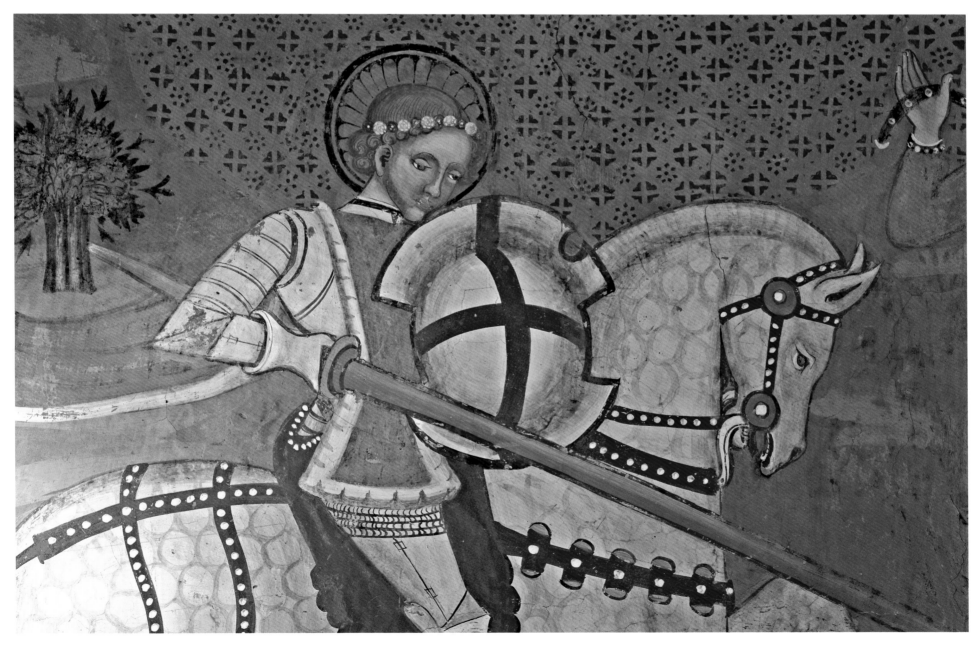

53. Das Kloster Sant'Alberto di Butrio. Kapitell mit Zopf-
muster und Tierszenen.
54. Das Kloster Sant'Alberto di Butrio. Sigismund, Kurfürst
von Brandenburg von 1378 bis 1388 und römisch-deut-
scher Kaiser von 1433 bis zu seinem Tod im Jahr 1437.
Fresko von 1484.

53. The monastery of Sant'Alberto di Butrio. Capitol with
a braided pattern and animal scenes.
54. The monastery of Sant'Alberto di Butrio. A figure of
Sigismund, Kurfürst of Brandenburg from 1378 to 1388
and Roman-German Emperor from 1433 until his death
in 1437. A fresco dating from 1484.

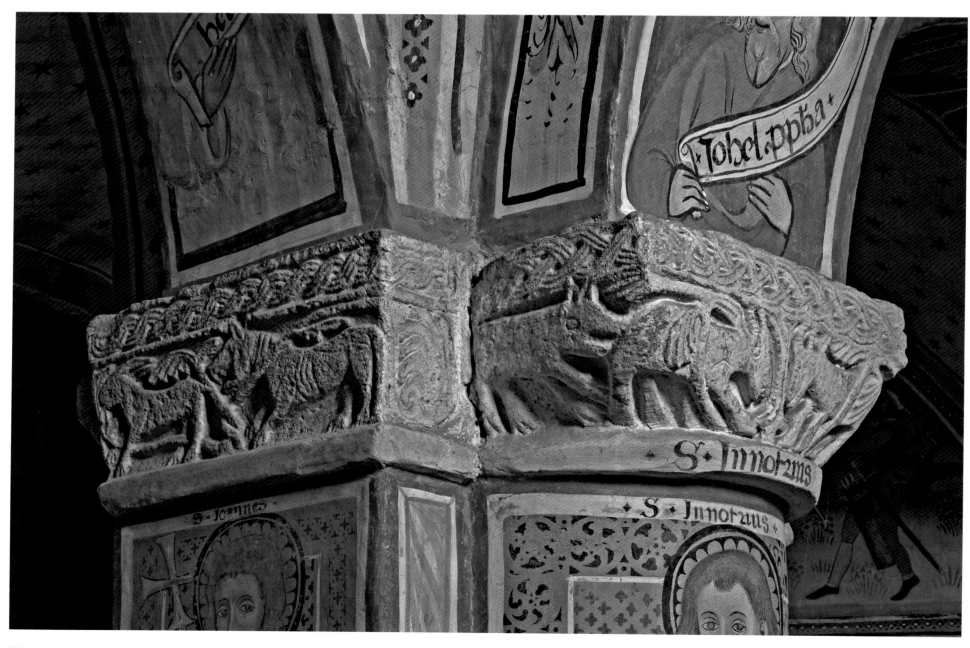

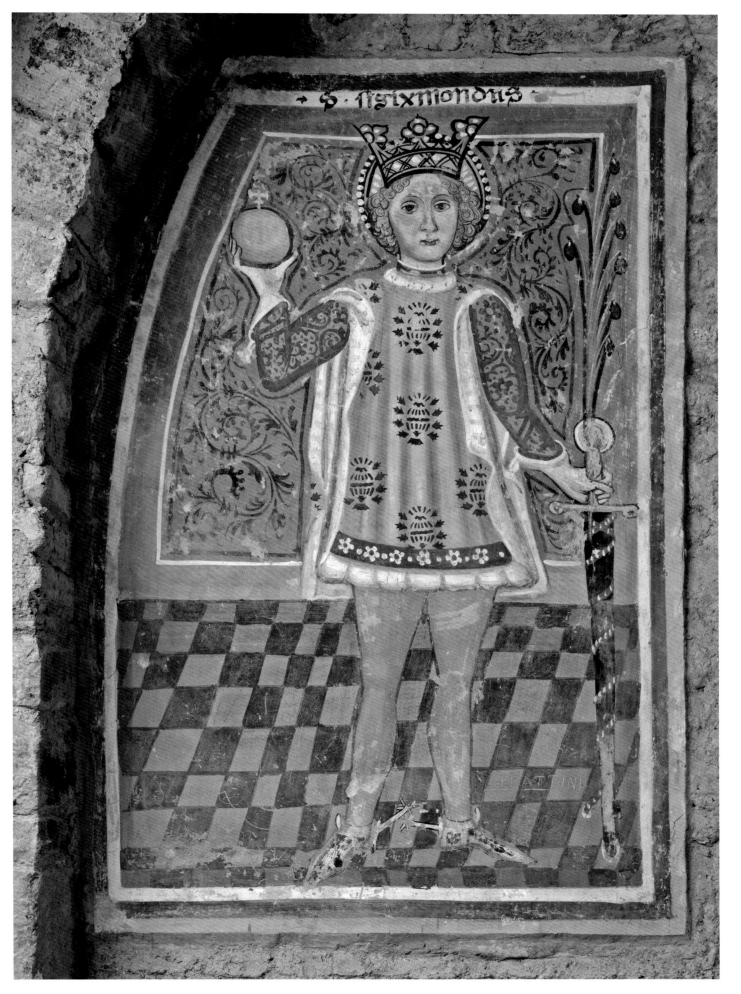

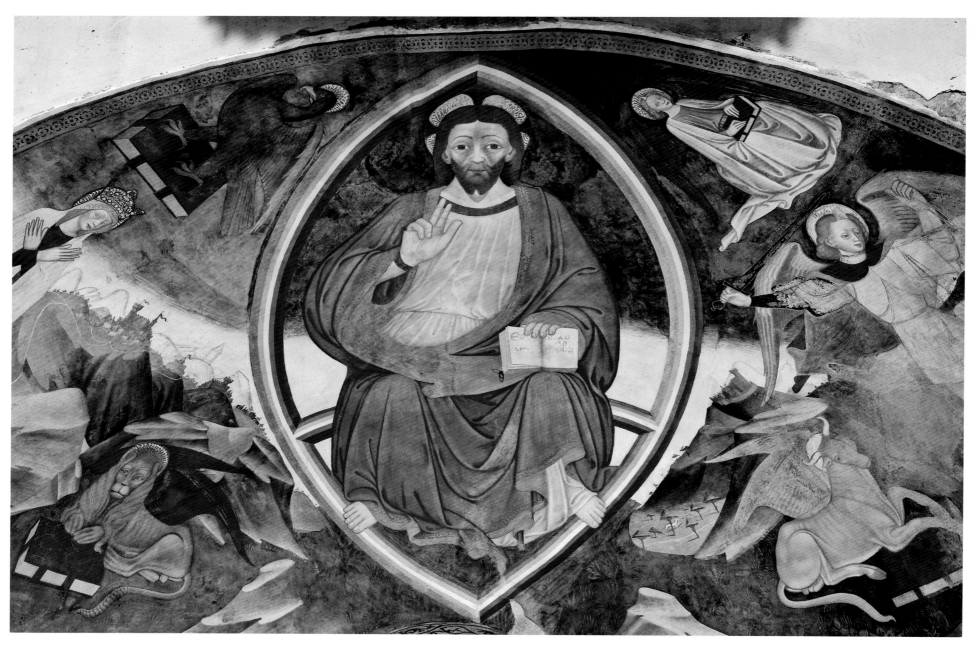

An adventure

The Aspromonte or »dark mountain« is the Italian peninsula's southernmost mountain massif. The Aspromonte extends a long way into the southern part of the Central Mediterranean, separating the Ionian Sea to the east from the Tyrrhenian Sea and the Straits of Messina to the west. Its highest point – the Montalto, or »high mountain« – stands at almost 2000 metres. The coast describes a southerly semicircle around it, from Bianco in the east on the Ionian Sea to Reggio di Calabria on the Tyrrhenian Sea in the west. There is seldom more or less than 20 kilometres as the crow flies between the coast and Montalto. The Aspromonte is a wild area, with short, deep valleys and steep slopes, with thick fern undergrowth, dense chestnut bosco and impressive pine groves. Even today, there are few roads.

I wanted to traverse a cross-profile of east Aspromonte – from Agata del Bianco, where the impassable part of the mountain begins, to Localitá Materazzelli, almost at the highest point. I was to be picked up that evening by a colleague in his rattling Beetle, travelling on the nearest road. It was a wonderful day. Below me was the deep blue of the Ionian Sea, and you could see the coast stretching far to the north – as far as Locri, the large Magna Graecia town. After a few hours, I met a shepherd, living miles from anywhere. I never passed a shepherd without stopping for a *chiachierata*, or little chat. We sat down, and he offered me strong-tasting, crumbly pecorino and hard bread. We talked about anything and everything, with the world spread out beneath our feet and his goats wandering through it peacefully, their bells clanking. After a long pause, he suddenly said: »I saw someone like you here once before.« I thought he was going to tell me about some butterfly collector or botanist, both of which I had met myself. Going on, he said: »That must have been about twenty or thirty years ago. He was a man who didn't work, like you.« I asked him what he meant by saying that I didn't work. »Well«, he said, »look at your hands.« He was right – when I held my hands up against his, it was as if they came from different worlds. He couldn't or wouldn't tell me any more about what had happened with the man years ago. The Aspromonte really is a dark mountain, where a lot of dark things are happening – abduction, exile, lying low and escapes.

A few hours later I came across a station manned by the Corpo Forestale. Its staff were well-armed, and clearly surprised to meet a man travelling alone through the Aspromonte. I didn't stay long because it was late and I wanted to get to Materazzelli by eight o'clock. After walking for roughly twelve hours, I reached the place where my colleague was supposed to meet me. I sat down on a fallen tree trunk and waited.

Complete silence fell all around me, and slowly but surely it got dark. No one came to pick me up. At nine, and at half past nine, I was still there. It was almost completely dark with very little moonlight, and I was cursing my colleague's unreliability. I mentally prepared myself to spend the night out in the Aspromonte, expecting it to be pretty cold at 1800 metres in late September. I wasn't afraid – after all, I was the only living thing in sight. Or so I thought. Suddenly, I heard the sound of an engine, and a VW Beetle slowly chugged into view.

I went towards the car, calling: »Hi – what took you so long?« Then I noticed that the car was beginning to drive off, without taking any notice of me. »Hey!«, I yelled at the top of my voice, »are you crazy? Stop!« The car actually stopped, and I went towards it – and found myself facing a gun pointed directly at me through the window by someone sitting in the back seat. It wasn't my colleague. There were four – in the fading light – dark figures. I asked if they had seen a VW Beetle with German plates. The driver replied that they had seen it leave about an hour ago. »What a mess«, I exclaimed, and explained to them who I was and what I was doing there. This was the beginning of my friendship with Marco Calcini, which lasted almost twenty years and ended only with his early death.

»No problem«, said Emilio, the driver, »you can come with us and sleep at our place. Tomorrow, on Sunday, we're going hunting. In the evening, we'll take you back to the coast.« I sat tight on the back seat between the two men. Now I saw that also the man on the right was holding a gun pointing out of the open window – not a shotgun, but a heavy hunting rifle. They were hunting wild boar – poaching, in short, and poaching in a rather bad way. The method would be to shoot the wild boar as they stood still on the road, blinded by the headlights.

On the trip home, Emilio asked me whether I really had come all the way from San Agata del Bianco. When I told him I had, he replied: »I'll never understand why you Germans lost the war.« That was more than thirty years ago, but I can still remember this strange answer perfectly. Around midnight, we arrived in Casa Cano, an extremely isolated forest house. It had two storeys, with three large rooms on the ground storey – one serving as a kitchen and dining room, and two bedrooms with iron bedsteads and bare mattresses, but with plenty of blankets.

There were at least ten men in the house – a real robber's den. There were lots of guns propped up in the corners. Someone, clearly a subordinate, was ordered to make the coffee, but I declined because I just wanted to go to bed. In the middle of the night, at about two o'clock, I was woken up by hushed voices. A car had driven up outside, and someone was knocking on the door. No-one answered it. »Chi é«, someone asked in a low voice, and another voice whispered »non lo so«. The car drove away without achieving its objective, and everyone lay down to sleep. It was a solid house, with metal doors and window shutters.

In the morning, after the best wash and brush-up I could manage under the circumstances and a breakfast coffee, a hunt took place. I was paired with Marco, who had a shotgun, and we trudged through the wonderful pine wood, remarkable for large pine cones. In any case, he shot a *scoiattolo* – a squirrel – which later formed part of our lunch. I asked him whether it wasn't dangerous to poach, and whether he wasn't worried about being caught. No, he said, it was Aspromonte that was a dangerous place. »Dangerous for whom?«, I asked. »Dangerous for anyone«, he replied.

Der Buonamico

Wilde Täler gehen vom Gipfel des Aspromonte, dem fast 2000 Meter hohen Montalto, aus, radialstrahlig, nach Osten, Süden und Westen, nur im Norden schließt sich eine Hochebene an. Der Fiumara Buonamico im Osten, der »gute Freund«, ist weder der größte noch der wildeste Fluß des Aspromonte, der Amendolea im Süden ist größer, und der Nachbar des Buonamico, der La Verde wilder. Das Tal des Buonamico umfaßt knapp 140 Quadratkilometer, und der Flußlauf hat eine Länge von 25 Kilometern; das ist, an kleineren deutschen Flüssen gemessen, gar nichts. Da Italien dort unten aber nur etwa 50 Kilometer breit ist, führt der Buonamico in seinem Bereich eben doch das Wasser aus halb Italien ab.

Geologisch und morphologisch, botanisch, zoologisch und auch ethnografisch oder kulturhistorisch betrachtet, bildet der Buonamico eine eigene Welt, einen ziemlich geschlossenen Mikrokosmos. An der Küste, wo die Eisenbahn und die Straße ihn überqueren, ist sein ödes Schotterbett, auf dem sich im Müll Schweine um das Fressen streiten, fast einen Kilometer breit. Das Hochwasser im Januar 1973 hatte den Mündungsbereich zwar freigespült und der Natur wieder den Vorrang zugewiesen, in der Zwischenzeit aber ist dort Buschwald entstanden und eine wilde Müllkippe. Vom Gebirge sieht man hier wenig, nur fern im Westen steht der Kamm, meist von dem hohen und drohenden Gewölk einer Westwind-Wetterlage überzogen. Hier, auf der östlichen, der ionischen Seite des Gebirges, auf seiner Leeseite, ist es oft sonnig und klar, während im Westen auf der Tyrrhenischen Flanke und im Gebirge Unwetter ihr Wesen treiben, mit wilden, schnell ostwärts wandernden Wolken und Nebelfetzen, die sich unterhalb des Kammes sofort auflösen.

Etwa neun Kilometer geht es flußauf, bis die Berge soweit herankommen und zusammenrücken, daß das Gefühl eines Tales entsteht, ein Eindruck, der sich bis zur Beklommenheit hin steigern wird. Aber noch sind wir nicht so weit. Die Ränder der kilometerbreiten Schotterbetten werden von Agrumen-Plantagen gesäumt, den *agrumeti*, ein Sammelbegriff für alle möglichen Zitrusfrüchte, für Zitronen, Apfelsinen und dergleichen. Es gibt dort riesengroße Zitronen, deren zentimeterdicke Schalen, gepreßt, betörende Stoffe freisetzen, die zur Herstellung von Parfümen und Kosmetikartikeln verwendet werden. Daneben leuchten im südlichen März prallgefüllte Apfelsinenbäume. Zwischen den Plantagen, im weiten Unterlauf des Buonamico, weiden Schafe und Ziegen, von Hirten und ihren Hunden bewacht, was sie dort fressen, bleibt ein Rätsel.

Oben in den Bergen liegt San Luca, die einzige Stadt oder vielleicht besser das einzige Dorf des Buonamico, seine Metropolis. San Luca ist zweigeteilt, das alte San Luca, ein Ort, der, vom Hauptweg abgesehen, nur aus Treppen besteht, ist urtümlich und steil auf schroffem Sandsteinfelsen gebaut. Das neuere San Luca liegt auf den weichen Tonen des Olisthostroms, einem kaum verfestigten Gestein, das bei längeren Regenfällen zu fließen beginnt und seine Bebauung, die gefährdeten Häuser, mit sich nimmt. Nach den sintflutartigen Regenfällen im Januar 1973 kam das ganze neue, die untere San Luca ins Rutschen, und es stellte sich die Frage, ob der Ort in die Küstenebene umgesiedelt werden müsse. Vergleichbares hatte es 1953 gegeben, als das Dorf Africo hoch in den Bergen des La Verde nach ähnlichen Regenfällen an die Küste zwangsumgesiedelt wurde, mit

bis heute nicht ausgestandenen sozialen Folgen. Aber der Regen ließ nach, der Olisthostrom beruhigte sich wieder, und heute, nach fast dreißig Jahren, steht San Luca noch immer auf seinem Platz und wartet auf den nächsten Großregen. Die Meteorologen sprechen von einem Rekurrenzintervall von etwa fünfundzwanzig Jahren, mit anderen Worten, etwa viermal in einem Jahrhundert gibt es solche katastrophalen Regenfälle, eine Besonderheit der Gegend. Es regnet dann an einem Tag soviel wie in Berlin in einem Jahr. Ein Landstrich ertrinkt.

Einer historischen Quelle zufolge handelt es sich bei dem heutigen San Luca um eine Neugründung, entstanden nach einem starken Regen im Jahre 1592, als der Vorgängerort Patamia, zwei Kilometer flußauf an steiler Klippe gelegen, verlassen wurde, an einem 18. Oktober, dem Tag des heiligen Lukas, daher der Name des Ortes. Oktober paßt zwar gut, weil diese Regenfälle häufig im Oktober auftreten. Doch erscheinen die Ruinen von Patamia zu frisch, um vier Jahrhunderte überstanden zu haben, deshalb ist einer anderen Quelle, die die Zerstörung von Patamia auf das große Erdbeben von 1783 zurückführt, eher zu vertrauen.

San Luca ist ein finsterer Ort, von Armut und Arbeitslosigkeit gezeichnet. Viele Autos haben ein deutsches Kennzeichen, meist aus dem Ruhrgebiet, ein erfolgreicher Gastarbeiter zieht oft das halbe Dorf nach sich. Die Kriminalitätsrate ist hoch, die Aufklärungsrate niedrig. Auf einem übergroßen Gewerkschaftsplakat vom 15. Mai 1973 werden unbekannte Täter gegeißelt, die ins Gemeindebüro einbrachen und wichtige Akten verbrannten. Beim Kartenspiel wurde einer erschossen, die Kneipe war brechend voll, aber die *carabinieri* fanden nicht einen Zeugen, vom Täter ganz zu schweigen. Ein *carabiniere* wurde am hellichten Tage auf den Serpentinen vor San Luca in seinem Auto durch Schüsse getötet, der Täter ist bis heute nicht gefaßt, und das Denkmal für den armen Mann bedachte man mit einem Kugelhagel. In San Luca sei man ehrlich, heißt es, hier erschieße man sich von vorn und nicht von hinten, wie in Africo Nuovo oder Platí.

Inmitten dieser düsteren Umgebung gibt es jedoch auch Bilder des Friedens, eine Frau etwa, die im roh gemauerten Eingang ihres Hauses steht und spinnt, bekleidet mit der unauffälligen Tracht der Einheimischen, einer dunklen, einfachen Bluse, einem kaum plissierten, knielangen, schwarzen Rock und einer ebenso langen, blauen Schürze aus derbem Stoff. Die Haare trägt sie straff zurückgekämmt, den langen Zopf mehrfach um den Kopf gelegt. Aus einem kugelförmigen Korb, der weite Öffnungen hat und mit dunkler Wolle gefüllt ist, zupft sie den Faden bis zur schnell sich drehenden freien Spindel, auf die er gewickelt wird.

San Luca ist der Geburtsort des Dichters Corrado Alvaro, der in den 1930er Jahren zeitkritische Geschichten schrieb. Ins Deutsche übersetzt wurde nur *Die Hirten des Aspromonte*, ein eindrucksvolles Bild der Armut und Rückständigkeit. Und auch mein Freund Marco Calcini wohnte hier, der viel zu früh starb. Die Familie soll vor ein paar hundert Jahren aus Spanien eingewandert sein. Die Calcinis besaßen sehr viel Land, sowohl in den Bergwäldern als auch in dem zur Küste hin breiter werdenden Tal, hier waren es Olivenhaine, die noch heute auf den offiziellen Kartenblättern nach ihnen benannt sind. Sie verkauften große Teile an den Staat und erwarben sich damit die Berechtigung, mindestens einen Wildhüter oder Forstaufseher zu stellen, das war Marco, nach seinem Tode wurde es sein ältester Sohn Flavio. Darüber

The Buonamico

Wild valleys radiate from the peak of the Aspromonte, the almost 2000 metre-high Montalto, to the east, south and west, but in the north it connects to a high plateau. The Fiumara Buonamico in the east, the »good friend«, is neither the largest or the wildest river in the Aspromonte – the Amendolea to the south is larger, and the neighbouring La Verde is wilder. The Buonamico valley is about 140 square kilometres in area, and the river's course is about 25 kilometres long – nothing compared to a small German river. But as this section of Italy is only about 50 kilometres wide, the Buonamico is the conduit for all the water in half of Italy – in its own area, that is.

Geologically and morphologically, botanically and zoologically – and also ethnographically, culturally and historically – the Buonamico is a world unto itself, a fairly closed microcosm. At the coast, where the railway and the road cross it, the barren gravel bed, where pigs fight for edible scraps in the rubbish, is almost a kilometre wide. The flood in January 1973 washed the estuary area clean and restored the supremacy of nature, but since then more brushy forest has sprung up and the place has returned to being a godforsaken rubbish heap. You can see little here from the mountains, only the ridge far to the west, usually covered by high, threatening clouds created by a west wind weather situation. Here, on the easterly, Ionian side of the mountains, on the lee side, the weather is often sunny and clear, while in the west, on the Tyrrhenian flank and in the mountains, bad weather predominates, with wild, wandering clouds speeding eastwards and scraps of fog that dissipate as soon as they fall below the ridge.

Nine kilometres upstream, the mountains close in and draw together, so that one feels one is in a valley – and the effect is about to become claustrophobic. But I am getting ahead of myself. The edges of the kilometre-wide gravel bed are lined with agrumenti, or citrus plantations – lemons, oranges and other fruits. Huge lemons with centimetre-thick rind grow here. Pressed, they produce a fantastic stuff that is used in the production of perfumes and cosmetics. In the southern March, the landscape is lit up by laden orange trees. Between the plantations, on the wide lower reaches of the Buonamico, sheep and goats graze, protected by shepherds and their dogs. What they eat is a mystery.

Above, in the mountains, is San Luca, the only town – or rather, the only village – in the Buonamico, and therefore its metropolis. San Luca is divided into two areas. The old San Luca – a place that, with the exception of the main road, mostly consists of steps – is primitively built on steep, rough sandstone rocks. The newer San Luca is built on the soft clay of an olistostrome structure, a barely consolidated rock liable to be weakened by heavy rainfall and take its development of high-risk houses with it. After the deluge of January 1973, the newer, lower San Luca area slipped, and a question arose as to whether the village would have to be moved to the coast. Something similar happened in 1953, when the village of Africo, high in the La Verde mountains, had to be relocated to the coast after similar rainfall, with social consequences that remain to this day. But then the rain subsided, the olistostrome settled, and today, after thirty years, San Luca still stands where it has always stood, waiting for the next major rainstorm. Meteorologists say that the interval of recurrence is about twenty-five years – in other words, a peculiarity of the location is for such a catastrophic rainstorm to come along four times in a century. On that day, it rains as much as it does in Berlin in a year. A stretch of land drowns.

According to a historical source, the San Luca of today was founded after a heavy rain in 1592, after the earlier village of Patamia, which was two kilometres upriver on steep cliffs, one 18th of October. This date – St. Lucas' Day – gave the new town its name. A flood in October – the month with the highest incidence of heavy rainfalls – makes sense. But the ruins of Patamia look too fresh to have lasted four centuries, making the source that puts the destruction of Patamia down to the great earthquake of 1783 more credible.

San Luca is a dismal place, characterised by poverty and unemployment. Many of the cars have German plates; most of these are from the Ruhr – where one guest worker is successful, often the whole village will follow. The crime rate is high and the crime solution rate is low. An oversized trade union placard from 15th May 1973 castigated the unknown miscreants who broke into a council office and burned important files. When a man was shot during a card game, the *carabinieri* found no witness, let alone the perpetrator – even though it happened in a crowded public house. A *carabiniere* was shot in his car in broad daylight on an S-bend in the San Luca road. The killer has never been found, and the poor man's memorial has been subjected to a rain of bullets. In San Luca, they say that San Luca people are honourable – they shoot people from the front and not from behind, like they do in Africo Nuovo and Platí.

Even in these dreary surroundings, there are peaceful images – for instance, a woman standing in the rough brickwork of her doorway and spinning, dressed in the modest local dress – a dark, simple blouse, an almost unpleated, knee-length black skirt and an apron of the same length made from coarse material. Her hair is sternly combed back, with the long braid coiled around her head. She is winding threads onto her rapidly spinning, free-hanging spindle from a spherical basket with large openings.

San Luca is the birthplace of the poet Corrado Alvaro, who wrote stories in the 1930s criticising the spirit of the times. The only one of these to be translated into German was *Die Hirten des Aspromonte*, an impressive depiction of poverty and backwardness. My friend Marco Calcini, who died too young, also lived here. His family were said to have arrived from Spain 200 years ago. The Calcinis owned a lot of land – in the mountain forests and in the valley that widens as it approaches the sea. Olive groves in this valley still bear their name on official maps. They sold large tracts of land to the state, receiving in return the right to serve as gamekeepers and forest supervisors. This role was filled by Marco – and, after his death, by his oldest son Flavio. This sale also gave the locality the right to send its unemployed citizens to work in the forest for one month in the year at the expense of the forest authority, the Corpo Forestale dello Stato. Marco used to organize whole legions of the unemployed to work in the forests, planting and maintaining paths,

hinaus erhielt der Ort durch den Verkauf das Recht, seine arbeitslosen Bürger einen Monat im Jahr auf Kosten der Forstbehörde, des Corpo Forestale dello Stato, im Walde zu beschäftigen. Marco organisierte dort den Einsatz ganzer Legionen Arbeitsloser, beim Pflanzen, beim Wegebau, zusätzlich finanziert durch ein Arbeitsbeschaffungsprogramm der Cassa per il Mezzogiorno, der staatlichen Organisation zur Unterstützung des italienischen Südens.

Marco war sozusagen der König des Buonamico-Tales. In Kalabrien gibt es ausgeprägte Familiendynastien, die die einzelnen Gebirgstäler unter sich aufgeteilt haben. Wehe dem Hirten, dessen Schafe aus Versehen ins Nachbartal wechseln. Morde waren fast an der Tagesordnung, und die Zahl der Entführungen ging erst in den letzten Jahren zurück. Bei meinem ersten Kalabrienaufenthalt wurde unten, im Olivenhain unter San Luca, mein Auto aufgebrochen und eine Kamera gestohlen sowie eine Stange Zigaretten, es war das einzige Mal, das mir dies in Italien zustieß. Damals kannte ich die Calcinis noch nicht, die mich, als ich dies einmal erzählte, ganz erschrocken fragten: »Du bist doch nicht etwa zur Polizei gegangen?« »Na klar«, sagte ich, »ich kannte ja niemanden.« Die *carabinieri* waren damals übrigens erfolgreich. Sie wußten, welcher Hirtenjunge für die Gegend zuständig war. Seinen Vater hatten sie kurz vorher beim Fahren ohne Papiere erwischt, jedoch nichts unternommen. Eine kurze Erinnerung an diesen Vorfall genügte, und am nächsten Tag war die Kamera wieder da.

Marco hatte neun Kinder, fünf Söhne und vier Töchter, alle von einer feinen, zarten Frau, die sich stets im Hintergrund hielt und meist Schwarz trug, weil ständig jemand in der Riesenfamilie gestorben war. Sie starb kurz nach Marco, aus Kummer, wie die Ärzte behaupteten, in Wirklichkeit an einer verpfuschten Tetanusbehandlung.

Wenn man San Luca verläßt und wieder in den Fluß hinabsteigt, sieht man am Ufer alte Olivenhaine mit gewaltigen Bäumen stehen. Im Winter, zur Zeit der Olivenernte, sind weithin bunte Kunststoffnetze über den Boden gespannt, um das Sammeln der Oliven zu erleichtern. Zum Ufer hin liegen Reste dicker Betonmauern, die von der Geröllfracht des letzten Hochwassers abgeschliffen wurden. Auf den Berghängen flußaufwärts, die jetzt fast zum Greifen nahe an den Fluß rücken, sind Gärten angelegt, umgeben von dichten Dornenhecken gegen die allgegenwärtigen Ziegen und Schafe. Vereinzelt ist der Klang einer Hacke zu hören, ein heiseres Lied, begleitet vom Bimmeln der Ziegenglocken, ein Bild ländlichen Friedens, man möchte nicht glauben, daß alle Leute hier aus San Luca kommen.

Hatte es lange kein Hochwasser gegeben, wurde eine Straße geebnet, die man, einige Fahrkünste vorausgesetzt, mit dem Wagen befahren konnte, am besten natürlich mit einem Geländewagen. War aber gerade Hochwasser, dann hat der Buonamico überall eigene Wege gesucht und gefunden und dabei alles zerstört, die Trampelpfade der Schafe und Ziegen, die Wege und die schwankenden Seilbrücken über die tiefen Schluchten. Im Hochsommer, wenn der Fluß wenig Wasser führt, ist dies kein Problem, zur Not muß man die Schuhe ausziehen und hindurchwaten, im Frühjahr aber, nach der Schneeschmelze, oder im Spätherbst, nach den ersten Regenfällen, wird der Buonamico zur donnernden Naturgewalt, an der man nur vorbeikommt, indem man auf das hohe Ufer ausweicht. Wenn sich dort jedoch eine Felswand befindet, dann ist das schnelle Ende der Exkursion angezeigt.

Nach einem einstündigen Fußmarsch über zwei Kilometer erreicht man den Costantino-Rücken. Am Costantino hat sich in der Nacht des 4. Januars 1973 eine gewaltige Naturkatastrophe ereignet, ein Bergsturz oder Erdrutsch. Der gesamte Costantino-Rücken, vom Fluß auf 1300 Metern Meereshöhe bis hoch zur Plaghe di Cucco auf 1200 Metern, also fast 1000 Meter hoch, der ganze Bergrücken somit setzte sich damals in Bewegung, rutschte in den Buonamico und auf der gegenüberliegenden Talseite fast 100 Meter wieder hoch. Gesteinsmassen können bei solchen Bewegungen bis zu 50 Stundenkilometer schnell werden. Der Bergsturz ereignete sich nachts, niemand kam zu Schaden, aber es muß ein gespenstisches Gefühl für die Bewohner von San Luca gewesen sein, als das Rauschen des Hochwasser führenden Buonamico fast schlagartig verstummte.

Am Tag darauf machte sich Marco mit Freunden auf den Weg, um nach dem Fluß zu sehen, der Buonamico war nur noch ein Rinnsal. Oben aber bot sich ihnen ein grandioses Schauspiel. Quer über das ganze Flußtal hatte sich der Riegel des Bergsturzes gelegt, er bildete einen 80 Meter hohen, natürlichen Staudamm. Dahinter staute sich, schmutzig braun und mit Treibholz gefüllt, ein langgestreckter See auf. Wenn dieser Damm bräche, so befürchtete man, würde eine gewaltige Flutwelle den Buonamico hinabrauschen und Eisenbahn und Straßenbrücke an der Küste mit sich reißen. Aber dazu kam es nicht. Das Wasser bahnte sich zuerst einen Weg durch den lockeren Damm hindurch, und einen Monat später, im Februar, als der See überlief, formte sich relativ langsam und friedfertig ein tiefes Tal im Damm mit riesigen Blöcken, seitdem rauscht es wieder unter San Luca. Ein restlicher See, der Lago Costantino, existiert noch heute, und der Buonamico ist emsig bemüht, diesen von oben her mit seinem Schutt aufzufüllen.

Aber ich habe vorgegriffen. Noch hat sich der Bergsturz nicht ereignet, und wir klettern den Buonamico weiter flußauf. Wir passieren eine enge Schlucht, etwa 30 Meter hoch stehen ihre Wände, später wird sie vollkommen zugeschüttet sein. Der Weg wird beschwerlicher, wir kommen durch das Vallone degli Oleandri zum Torrente Cunello, der hier auf den Buonamico stößt und trauen unseren Augen nicht, da steht doch wirklich eine große Brücke, die den Fluß in sauber gemauertem Bogen überspannt, und vorn nichts und hinten nichts als die Trampelpfade von Ziegen und Schafen. Ein Monument der Sinnlosigkeit, von irgendeinem Programm irgendwann in die Bergwelt gesetzt, niemand konnte uns den Grund verraten. Diese Narretei wurde später durch das Hochwasser von 1973 beseitigt, fast spurlos, bis auf ein gewaltiges Stück Mauerwerk, das sich sieben Kilometer flußabwärts halb vergraben in den Schottern fand. Archaische Kräfte müssen in jener Nacht im Buonamico getobt haben.

Immer enger rücken die Ufer aneinander, immer komplizierter wird es, den kleinen Wasserfällen und Wannen voller Wasser auszuweichen. Der Buonamico beschreibt jetzt einen kleinen, nördlichen Bogen und trifft, nach Süden zurückkehrend, auf die berühmteste Lokalität des Tales, ja des ganzen Aspromonte, auf den Convento Madonna di Montagna, auf das Santuario di Polsi, eines der größten Heiligtümer Kalabriens, ein Wallfahrtsort, der Tausende anzieht. Polsi ist eine vermutlich basilianisch-normannische Gründung aus dem 12. Jahrhundert und seit einigen Jahren über eine, wenn auch recht mühevolle, Straße mit der Außenwelt verbunden.

1. Blick von den Bergen des oberen Fiumara Laverde zum Montalto (1955 m), dem höchsten Berg des Aspromonte.
2. Blick auf den Monte Perre (1387 m) über dem Tal des Butramo, des größten Nebenflusses des Fiumara Buonamico.

1. A view of the mountains on the upper Fiumara Laverde towards Montalto (1955 m), the highest Aspromonte mountain.
2. View of Monte Perre (1387 m) over the valley of the Butramo river, the largest tributary of the Fiumara Buonamico.

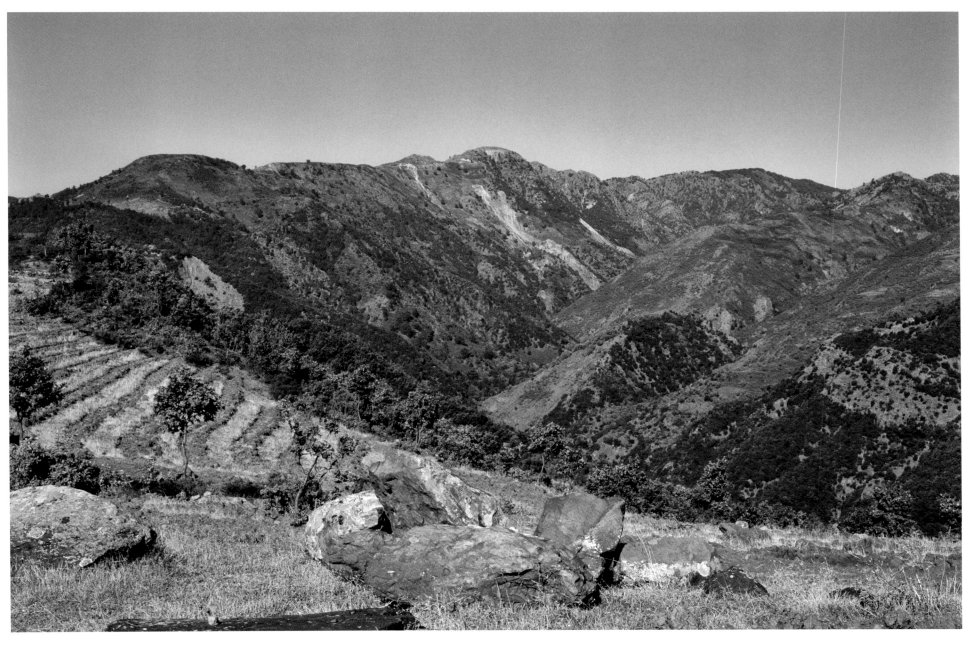

3. Aspromonte, Blick auf den Monte Scorda (1572 m) über dem Vallone Aurea, einem Nebenfluß des Fiumara Buon-amico.
4. Pinien im Aspromonte.

3. Aspromonte. A view of Monte Scorda (1572 m) across the Vallone Aurea river, a tributary of the Fiumara Buonami-co.
4. Pines in Aspromonte.

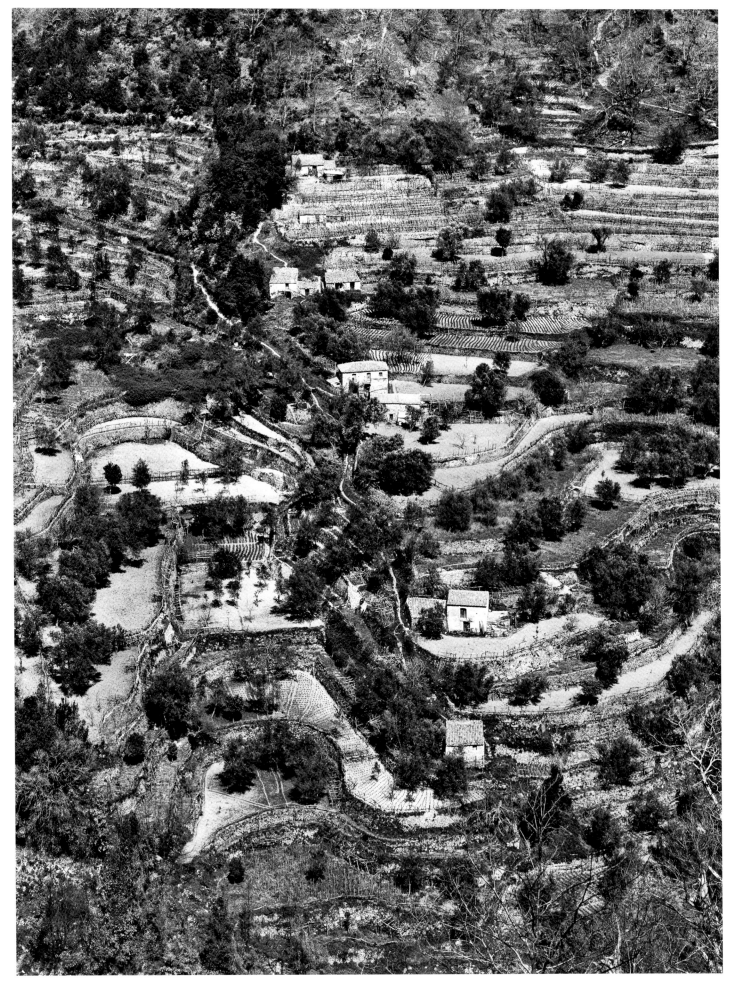

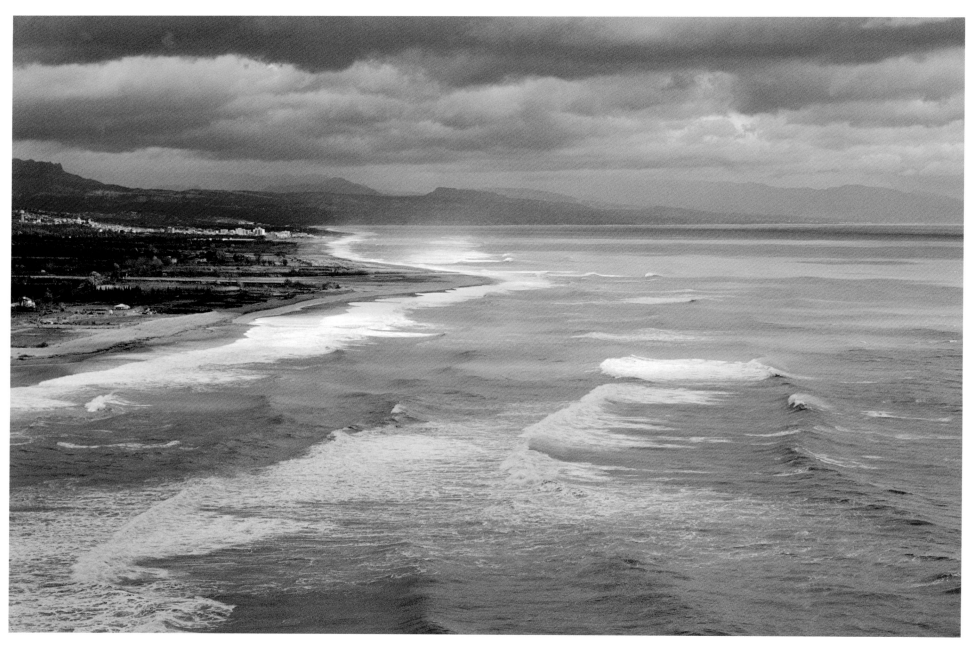

29. Köhlerei bei Serra San Bruno. Stapelplatz mit sortiertem Stangenholz.
30. Köhlerei bei Serra San Bruno. Der Meiler wird mit dicken Erdschollen bedeckt.

29. Charcoal burning near Serra San Bruno. A woodpile with sorted sticks of timber.
30. Charcoal burning near Serra San Bruno. The charcoal pile is roofed over with heavy clods of earth.

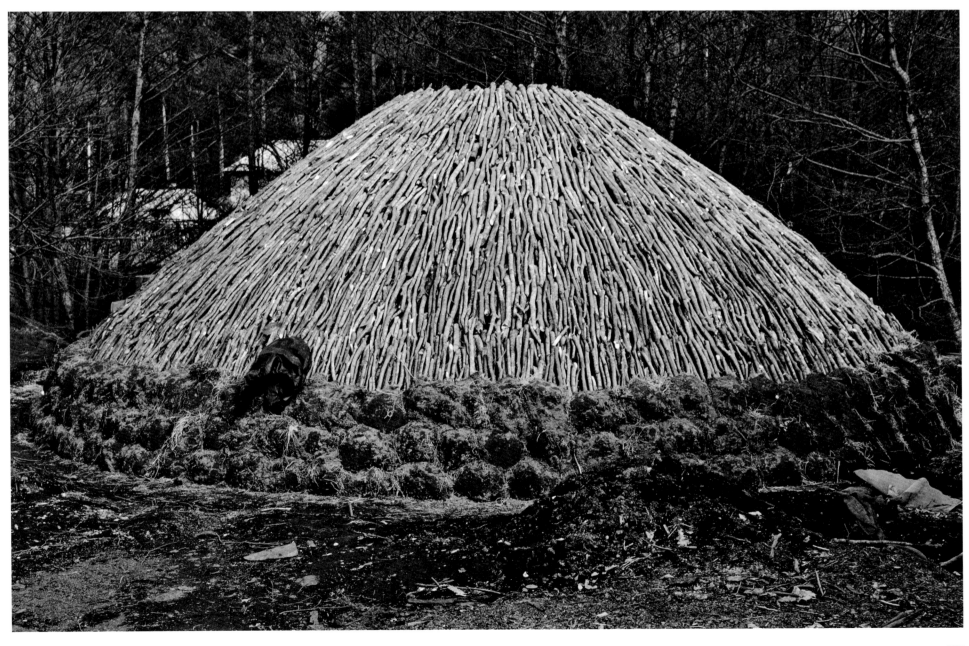

41, 42. Stilleben im Olivenhain der Contrada Scoglio,
Bianco.

41, 42. Still life in the olive grove of the Contrada Scoglio,
Bianco.

43. Stilleben an der alten Ölpresse der Contrada Scoglio, Bianco.
44. Bei den Hirten. Kessel und Schöpfgefäße zur Vorbereitung von Ziegenkäse.

43. Still life at the old Contrada Scoglio olive press, Bianco.
44. By the shepherds. Kettles and bowls for making goat's cheese.

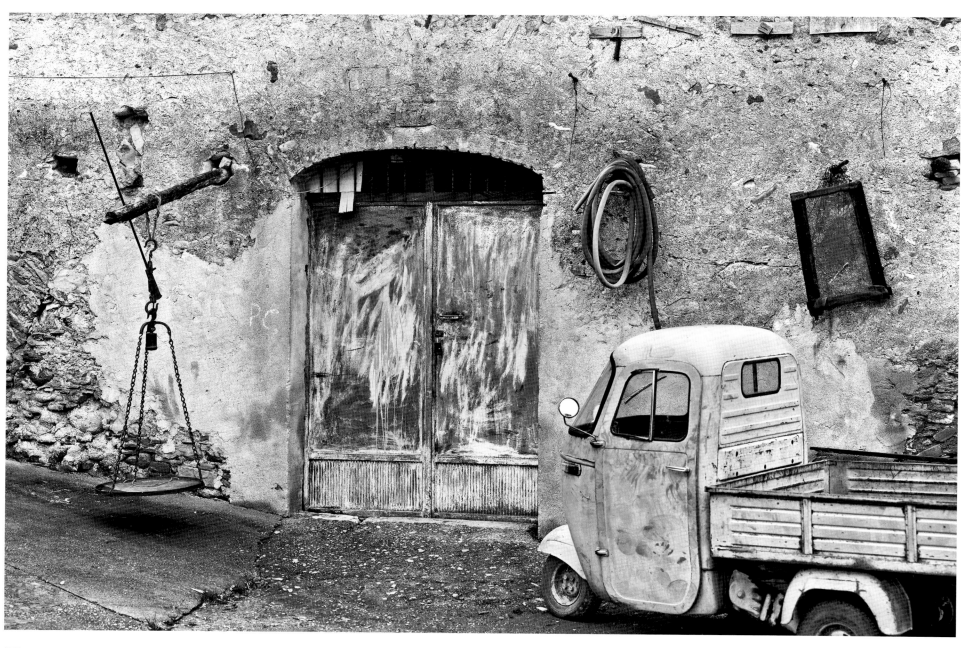

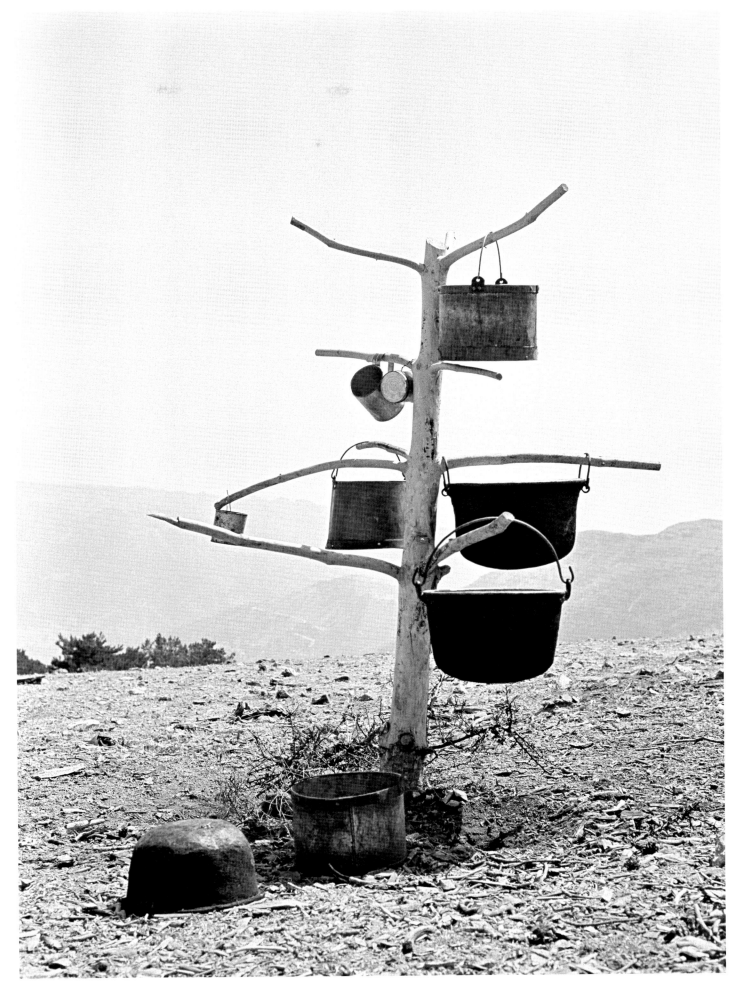

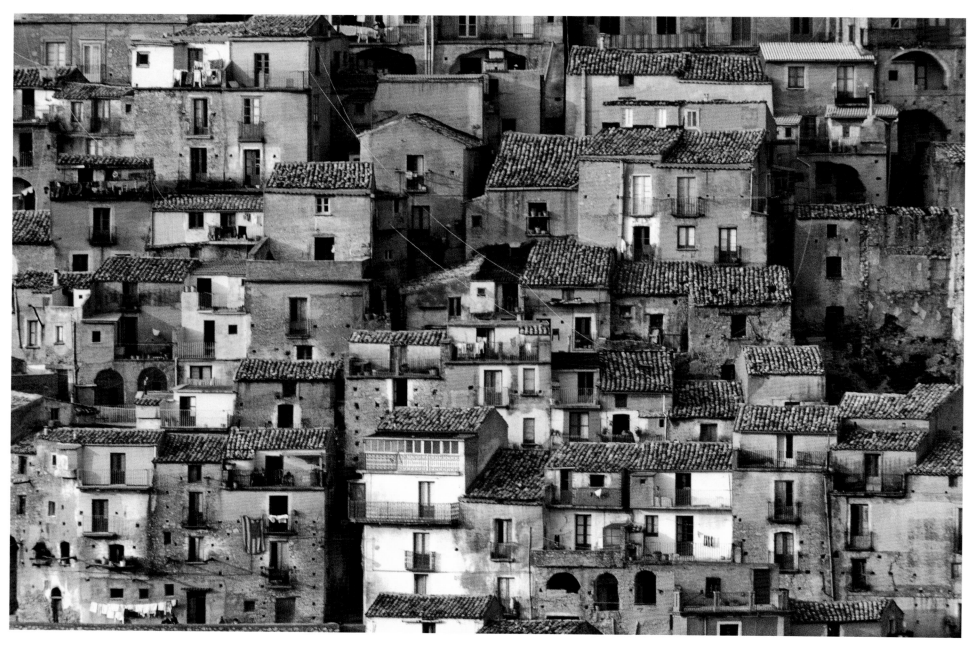

55. Kalabrien ist berühmt für seine Töpferwaren. Das Bild entstand in Polístena auf der tyrrhenischen Seite des kalabrischen Massivs.
56. Winter in Bianco. Das Strandcafé ist abgeräumt.

55. Calabria is famous for its pottery. This picture was taken in Polístena on the Tyrrhenian side of the Calabrian massif.
56. Winter in Bianco. The beach café has been cleared away.

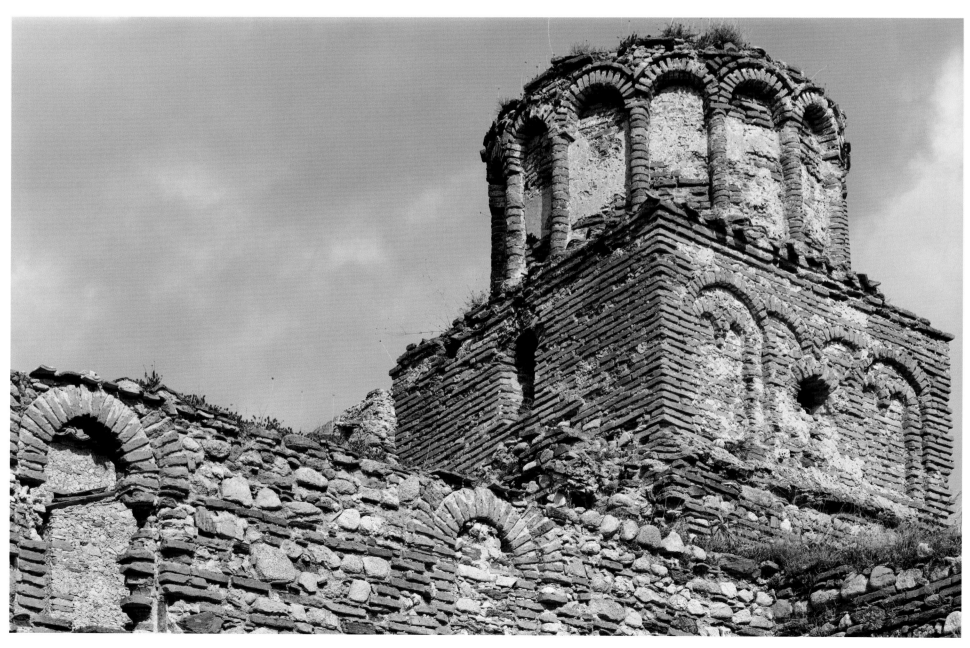

57. Die Klosterkirche San Giovanni Theristis bei Bivongi/ Stilo ist eine Ruine. Der byzantinisch-normannische Bau stammt aus der Mitte des 11. Jahrhunderts.
58. Die Cattolica von Stilo. Dieses rein byzantinische Kirchlein stammt aus dem 9. Jahrhundert.

57. The monastery church of San Giovanni Theristis near Bivongi/Stilo is a ruin today. This Byzantine-Norman building dates from the middle of the 11th century.
58. The Cattolica of Stilo. This small, purely Byzantine church dates from the 9th century.

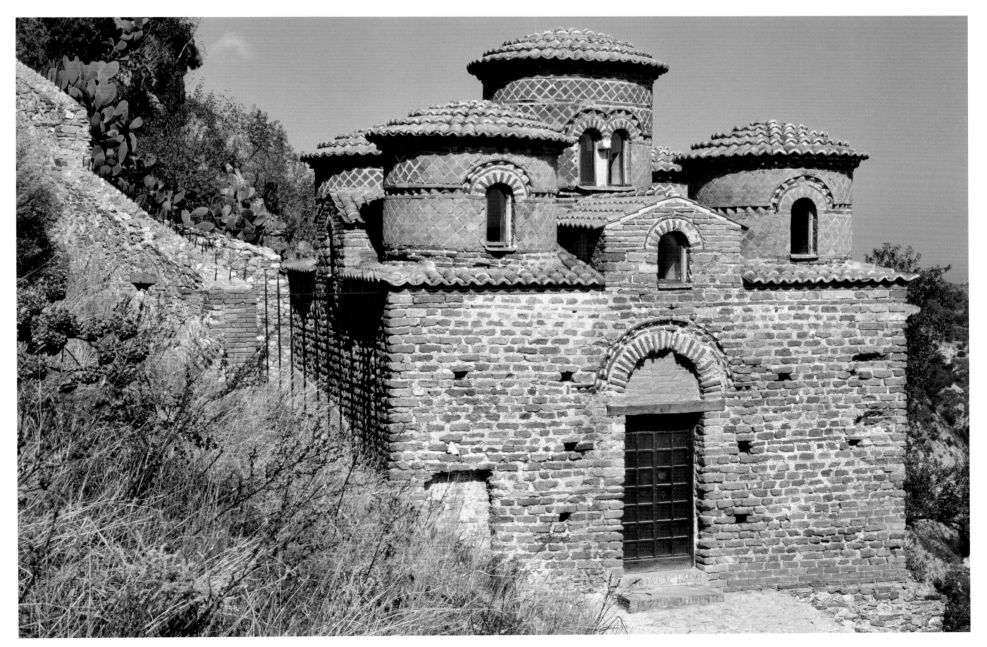

Die Zeit danach

1959 bis 1989, das sind zehn Jahre Ligurien und zwanzig Jahre Kalabrien, zusammen also dreißig Jahre das andere Italien. Wir schreiben aber 2010, und nach dem Ende der italienischen Projekte sind wir, meine Frau C. und ich, jedes Jahr für Wochen in »unserem« Italien gewesen, auch wieder zwanzig Jahre lang, so daß ich jetzt auf fünfzig Jahre Italien, wahrhaftig ein halbes Jahrhundert in diesem wunderbaren Land, zurückblicke.

In Kalabrien ist eigentlich alles beim Alten geblieben, die Zeit blieb stehen. Wir wohnen bei demselben Bauern in demselben kleinen Appartement und schlafen in denselben Betten wie immer. Bauersfrau und Schwägerin, die ein kleines Restaurant an der Bahn, fast unmittelbar am Meer betreiben, bekochen uns abends unverdrossen, sie machen nur für uns auf, sonst kommt niemand. Tagsüber gehen wir gern die menschenleere Küste entlang oder fahren ins Landesinnere, etwa nach Serra San Bruno. Das Meer ist eigentlich immer recht stark bewegt, es kennt keine Ruhe. Das liegt nicht zuletzt daran, daß nach Südosten, wo das Wetter oft herkommt, eine fast 800 Kilometer lange Wasserfläche über das Ionische Meer hin bis nach Libyen reicht, die schickt oft ausgedehnte Seegangsfelder gegen die Küste.

Im Gebirge würden wir gerne ein wenig wandern, eine Höhenstraße entlang oder in einem Flußbett. Aber das geht leider nicht, die Gegend ist einfach zu unsicher. Ich traue mich nicht, den Wagen längere Zeit unbeaufsichtigt stehen zu lassen. Nicht, daß er gleich geklaut würde, das kann überall vorkommen, nein, die gelangweilten Hirtenjungs machen sich gerne einen kleinen Spaß und rammen ein paar Grashalme oder dünne Ästchen in die Türschlösser, die man dann kaum aufgepult bekommt. Oder sie lassen die Reifenluft ab, natürlich nicht nur an einem Rad.

Es gibt aber noch persönliche Bindungen hinab in die Vergangenheit, von dem Freundessohn ganz abgesehen. Es kann passieren, daß wir vor der Bar an der *piazetta* von Bianco unseren abendlichen Aperitif trinken. Dann kommt jemand vorbei, ein Älterer oder Alter natürlich, und winkt uns im Vorübergehen zu. Wenn ich dann in die Bar hineingehe, um zu bezahlen, dann heißt es »già pagato«, schon bezahlt. Es ist nachgerade ein italienischer Sport, Freunde an der Bar einzuladen, nur die Römer sollen sich nicht daran halten, sagt man.

An der Küstenstraße, kurz vor unserem Bauern, gibt es einen Delikatessenladen, dort versorgen wir uns, wenn wir im Gebirge picknicken wollen. Die Chefin des Ladens, eine reizende Frau, fragte mich, ob ich der Geologe wäre, der Anfang der 1970er Jahre im Hotel Victoria gewohnt habe, ihr Vater hätte dort als Nachtportier gearbeitet, sie muß damals ein kleines Mädchen gewesen sein. Er habe oft von mir erzählt. Der Nachtportier war damals von großer Wichtigkeit für meinen Kollegen und mich. Wir kartierten den Meeresboden auf dem schmalen Schelf mit einem kleinen Echographenboot. Wir hatten in den ersten Tagen im Wortsinne fast Schiffbruch erlitten, weil wir das kleine Boot vormittags kaum in das aufgeregte Meer bekamen, einen Hafen gibt es dort nicht, alle Boote werden über Nacht aufs Ufer gezogen. Bis wir von den Fischern lernten, daß man vor Sonnenaufgang draußen sein muß, bei ablandigem Wind, dann ist das Meer ruhig. Vormittags, wenn sich das Land aufheizt, steigt die Luft dort auf und saugt die anlandigen Winde an, die uns so zu schaffen machten. Der uralte Rhythmus der Fischer: frühmorgens ausfah-

ren, am späten Vormittag zurückkehren. Das bedeutete für uns, daß wir wochenlang morgens um vier Uhr aufstehen mußten, um zum Sonnenaufgang so gegen fünf Uhr auf dem Wasser zu sein. Da es so früh nirgends ein Frühstück gibt, machte uns der gute Nachtportier immer wenigstens einen *espresso*, so überlebten wir. In Italien wird das Wort Frühstück ohnehin klein geschrieben. Das wußte also die Tochter, wir lassen den Nachtportier herzlich grüßen, heute lebt er wohl nicht mehr und der Delikatessenladen hat auch den Besitzer gewechselt.

Auch in dem anderen, dem ländlichen Ligurien hat sich kaum etwas verändert. Es gibt keine neuen Straßen, kaum neue Häuser in den Dörfern, nur die Wege im Gebirge verfallen, die *mulattiere*, auf denen die Bauern das Stangenholz der Kastanienwälder transportierten, das Brennmaterial der Vergangenheit. Heute brennt Methan in fast jedem Herd, und Bauern gibt es kaum noch. Auch die terrassierten Felder der Gebirgsdörfer werden, ungenutzt, von Büschen überwuchert, die Mauern verfallen.

Freunde von damals existieren nicht mehr. Die älteren sind alle tot, die Gleichaltrigen, nun auch schon alt, sind verzogen, verschollen, in alle Winde zerstreut. Aber, und das ist der Unterschied zu Kalabrien, es gibt neue Freunde, neue Bezugspunkte. An der Borbera-Brücke vor Rocchetta gibt es ein kleines Hotel, das erst eröffnete, als ich den Nordapennin verließ. Dort sind wir nun auch schon wieder über zwanzig Jahre enge Freunde geworden, wir erlebten die Entwicklung der Familie, die Heirat der jungen Leute, die Geburt der Enkel, die Eltern, die Großeltern, so alt wie wir, und, ja, den Urgroßvater, den »Nonno«, der erst vor zwei Jahren starb und auch eine ligurische Geschichte bekommen hat. Wir haben »unser« Zimmer, »unseren« Tisch im Restaurant, trinken »unseren« Wein. Der gelegentliche Kontakt zwischen Berlin und Rocchetta läuft, Kind unserer Zeit, jetzt allerdings über E-mail, insofern hat sich doch etwas geändert. Aber es gibt noch eine, eine wesentliche Erneuerung: Überall auf dem Lande, in den winzigen Dörfern, haben sich Feinschmecker-Lokale herausgebildet, ausnahmslos Familienbetriebe, die mit ihren Köstlichkeiten wetteifern. Es ist eine richtige Gastronomie-Szene entstanden mit Häusern, die sich in umfangreichen, üppig bebilderten Sammelprospekten anpreisen und bestimmte Tage im Jahr mit bestimmten Spezialitäten aufführen, es ist eine Trüffelgegend. Wir machen uns inzwischen einen Sport daraus, möglichst viele dieser wunderbaren und zumeist unglaublich geschmackvoll eingerichteten Restaurants während eines Rocchetta-Aufenthalts zu besuchen. Wir bestaunen immer wieder die italienische Herzlichkeit, fast überall werden wir empfangen wie lang entbehrte Freunde, Küßchen hier, Küßchen dort. Viele Jahre verbrachten wir sogar Weihnachten in Rocchetta, um dem heimischen Trubel zu entgehen, »*Presepe vivente*« berichtet davon, aber die Tage sind dann zu kurz, man ist auf das doch sehr schlichte Zimmer angewiesen, und des öfteren gab es auch Wetterprobleme. So sind jetzt Frühling und Herbst unsere bevorzugten Zeiten, und wir können nur hoffen, daß dieses andere Italien uns, und wir ihm, noch möglichst lange erhalten bleiben.

The time thereafter

From 1959 to 1989, I spent ten years in Liguria and twenty years in Calabria – taken together, thirty years in »the other Italy«. But at the time of writing, in 2010, long after the completion of my Italian projects, my wife C. and I have also been spending several weeks every year in »our« Italy for twenty years. I can now look back on fifty years of Italy – half a century in this wonderful country.

In Calabria, everything is still the same. Time has stood still. We still stay with the same village family in the same little apartment and sleep in the same beds as we did all those years ago. The wife and sister-in-law, who keep a little restaurant on the route that runs almost directly by the sea, cook for us in the evening tirelessly, even though we are their only customers. During the day, we like to walk along the deserted coastline, or go on drives into the interior, perhaps to Serra San Bruno. The sea is constantly in violent motion, never coming to rest. The reason for this is the almost 800 kilometres of water to the south-east, between Calabria and Libya on the other side of the Ionian Sea. This is where most of the weather comes from, accompanied by broad expanses of heavy seas beating against the coast.

We would like to do a little rambling in the mountains, along one of the high roads or a river bed. Unfortunately, the region is simply too unsafe for this. I wouldn't want to leave the car unattended for any length of time. Not because it might be stolen – that could happen anywhere – but because bored shepherd boys in search of a little fun sometimes put a few blades of grass or thin sticks in the locks, and these are almost impossible to pull out. Or they might let the air out of the tyres – and not just on one of the wheels.

We do still have personal links with the past, quite apart from my old friend's son. Occasionally, as we drink our evening aperitif in the bar of the *piazetta* of Bianco, someone will pass by – a middle-aged or old person – and give us a nod in passing. And then, when we go into the bar to pay, we will be told: »Già pagato« – »paid already.« Italians make a sport of buying friends drinks in this way – I have been told that the only place where this custom is not observed is in Rome.

There is a delicatessen shop on the coastal road – just ahead of the house of the village family we stay with – and we pick up supplies there when we go on a picnic in the mountains. One day, the lady chef at the shop – a charming woman – asked me if I was the geologist who had stayed at the Hotel Victoria in the early 1970s. Her father had been working there as a night porter when she was just a little girl, and he had talked about me a lot. Back then, when we were surveying the seafloor of the narrow shelf with our small echograph-enabled boat, the night porter was a very important person as far as my colleague and I were concerned. In the early days, we were almost shipwrecked (literally) because we nearly failed to get the boat out of the restless sea in the morning. There wasn't a harbour, and all the boats were drawn up on the shore for the night. That was before we learned from the fishermen that you had to put your boat out before the sunrise, when the wind is blowing offshore and the sea is calm. In the morning, when the land is heating up, the air over the land rises, drawing the onshore wind in – and it was this wind that had given us so much trouble. The ancient rhythm of fisherpeople: set out in the early morning, return in the late morning. For weeks, we got up at four in the morning, so we could be on the water when the sun rose: at about five in the morning. As it was impossible to get breakfast anywhere at this time of day, the night porter was kind enough to always get us at least an *espresso*. And so we survived. (Italians do not bother much with breakfast, as a rule). The night porter's daughter knew all about this story. We sent him our best wishes. By now, he is probably dead, and the delicatessen has changed ownership.

The »other«, rural Liguria has not changed much in the past fifty years either. There are no new roads, no new houses in the villages. The mountain paths, the *mulattiere* the farmers used to use to transport sticks from the chestnut woods, once essential fuel, are neglected. Today, almost all the stoves burn methane, and hardly anyone lives by farming. Unused, the terraced fields of the mountain villages are being overgrown by bushes, and the walls are crumbling.

My friends from the old days aren't around any more. The older ones are dead, and the ones of the same age as me, who are now old, have moved away and been forgotten, scattered to the four winds. But – and this is the difference between Liguria and Calabria – they have been replaced with new friends and new special places. For instance, the little hotel on the Borbera bridge near Rocchetta. We have been going there for twenty years, and we have seen the family grow up, seen the young people marry and the birth of grandchildren. We have known the parents, the grandparents, who are now the same age as us – and the great grandfather, the »Nonno«, who died a few years ago. His was also a Ligurian story. We have »our« own room and »our« own table in the restaurant, and we drink »our« wine. There is a steady if occasional Berlin–Rocchetta contact. Admittedly, this correspondence is a child of its time and takes place mainly by e-mail – that's one thing that has changed. But there has also been a rather more significant change. All over the rural landscape, in the tiny villages, gourmet restaurants have sprung up. They are all family businesses, vying to produce the best delicacies. A real restaurant industry has emerged, with restaurants advertising in extensive and well-illustrated collective prospectuses and laying on specialities on certain days of the year. The region is also a truffle-growing area. We have made a sport of visiting as many of these wonderful and generally tastefully furnished restaurants as possible during our visits to Rocchetta, although we generally do not visit as many as we mean to. We are amazed by Italian warmth and hospitality – almost everywhere we are received like long-lost friends, with showers of kisses. For many years, we even spent Christmas in Rocchetta, to avoid all the fuss at home. I tell about this in the story *»Presepe vivente«*. However, we decided to stop doing this because of the short days at that time of year, the very spartan accommodation and the frequent problems with the weather. These days, we prefer to be there in the spring or in the autumn. We can only hope that this »other Italy« continues to endure, and that we will be able to enjoy it for many years to come.